HIROSADA
ŌSAKA PRINTMAKER

The University Art Museum
California State University, Long Beach
September 6–October 7, 1984

The Museum of Fine Arts, Houston
October 30–December 31, 1984

An exhibition organized by
The University Art Museum
California State University, Long Beach

Guest Curator, Roger S. Keyes
Edited by Jane K. Bledsoe

©1984 The University Art Museum
California State University, Long Beach
All Rights Reserved

ISBN: 0-936270-22-5

CONTENTS

INTRODUCTION

The prints of Ōsaka are less well known than those from Edo (Tokyo), partly because they have been the victim of prejudice against that which was considered provincial (Edo was the cultural as well as political capital during the Tokogawa Shogunate [1600–1868]), partly because of their own scarcity and partly because these prints, unlike those from the Edo, were limited almost entirely to actor portraits rather than the more varied and popular subjects common to most *ukiyoe* prints. That this oversight is more than a little regrettable is readily apparent after the most cursory glance at the woodblock prints of Konishi Hirosada who, except for brief periods of study in Edo, lived and worked in Ōsaka. As Roger Keyes demonstrates, Hirosada was not only a superbly accomplished artist, he also contributed brilliant innovation to woodblock print design that would influence the work of artists such as Kunisada whose prints are better known to Westerners.

The majority of Hirosada's prints portray the actors of the kabuki theatre in specific roles and were dated (and issued) to correspond to a particular performance of the play. Because kabuki was a theatrical form dedicated to the diversion of the senses rather than the development of the intellect, it was actively disdained by the warrior and noble classes of Japan who preferred the Nō drama as the appropriate expression of upper-class elegance and good taste. Although kabuki was officially scorned and often censored for its sensuous and extravagant staging of convoluted stories of romance, subterfuge, heroism and tragedy that rival contemporary American soap operas, its mass appeal cut across all class barriers.

Kabuki has long since overcome its plebian connotations and today surpasses the Nō theatre in general appeal. It has also recently begun to receive recognition from American audiences who appreciate the vivid costumes and visual

presentations and the (to Americans) exaggerated and theatrical gestures of the actors. The actors, like the performers of western theatre, movies and, now, television, garnered considerable public acclaim which, in turn, contributed to the popularity of the actor prints and led to their collection and preservation in albums by loyal fans.

Kabuki, literally, "thing leaning" or "extraordinary thing," with a connotation of something degenerate or unorthodox, emerged as an indigenous theatre of Japan in 1603. Its origination is credited to the *miko*, or Shinto shrine virgin, Okuni, who in the year 1600 began performing an embellished version of the prayer-dance *nembutsu-odori* (dance of prayer to Buddha) on a temporary stage erected in the Kamogawara district of Kyoto. Okuni was soon joined by Nagoya Sanzaburo (Sanza), a wealthy young man about town who was known as an accomplished musician and performer of *Kyogen* (Nō comic interludes). The couple, Okuni dressed as a male dancer and Sanza as a female, sang ribald lyrics and performed dances with overtones of obsenity and quickly gained immense popularity. Although Sanza soon tired of the floating world and returned to the samurai life to which he had been born (he died in a quarrel in 1604) and the later years of Okuni are shrouded in a jumble of confused conjecture, the major elements of kabuki — sensuous performance, cross sexual impersonation, elaborate and exotic costuming and mass appeal — had been firmly established.

In the intervening years between the early formative stages of kabuki and the mid-nineteenth century when Hirosada designed the prints in this exhibition, many changes were to occur. By 1629 women were banned from performing roles in order to "protect" the samurai and official classes from the decadence and excessive expenditures often associated with attending the theatre and entertaining the actresses. The banishment of women from the kabuki stage did not, how-ever, remove the female roles from the performances. Instead, following the precedent established by Okuni and Sanza, the role of the *onnagata*, the female impersonator, was developed. In order to attract and hold larger audiences, plays rather than the original song and dance routines were introduced and, with the more complex dramas, staging also became more sophisticated. Eventually drawn curtains were introduced to facilitate scene changes and the temporary outdoor stages were abandoned in favor of permanent indoor theatres.

During the Genroku era (1688–1703) middle class Japanese culture reached maturity and along with the expanded influence of the merchant class, kabuki also came of age. Dramatists produced plays in multiple acts with complex plots and, encouraged by the public demand for beauty and entertainment, the actors developed *kata*, the stylized forms of acting, dancing and elocution, makeup and hairstyle, costuming, accompaniment, and stage properties and settings which were to constitute the classical kabuki style. However, although kabuki had reached maturity as a theatrical form, it was not to be accorded recognition as a classical theatre for another two hundred years.

Instead, kabuki was to be alternately restricted and at times completely banned, then allowed to flourish (frequently by default as the authorities ignored rather than recinded regulations) in accordance with the continual attempts of the Tokogawa Shogunate to control economic and social conditions. These various strictures, beginning with the banishment of women from the kabuki stage to regulations designed to force compliance with successive sumptuary laws and decrees, perversely seemed to promote ingenious methods for achieving the effect of lavishness without the substance of luxury. Forbidden to use silk for costumes, designers substituted ramie whose lustrous sheen resembled the proscribed fabric; denied the use of satin, lesser materials were exquisitely

embroidered or appliqued, since embroidery and applique as such were not banned. Often the costumers would make use of rare imported Dutch cottons, which, since they were unfamiliar to the governmental inspectors, were not recognized as expensive, rare and exotic (and therefore illegal) materials.

Because of their role in the promotion of kabuki, actor prints were also frequently proscribed. Hirosada worked during one such period, the so called Tempō Reforms. The effect that the restrictions of this period had upon his work is described in Dr. Keyes' essay. Actor prints served to commemorate performances of particular roles by specific actors. They would be issued to coincide with the performance and would be purchased by fans of the actor. The prints were saved in albums or bound books. The closest comparison in contemporary western practice is a scrapbook of memorabilia such as playbills, press clippings and studio photographs of stage and screen stars that an avid, and typically teenaged female, admirer might assemble. It is, however, a pale comparison. The kabuki fan was a serious connoisseur not only of the theatre but of the actor prints. Although many of these prints were inexpensively produced, a great number were published in editions which can only be described as stunning. Not only is the workmanship of outstanding quality, the luxurious papers and inks indicate the presence of an affluent and discriminating clientele.

This exhibition, the first ever devoted entirely to Konishi Hirosada, printmaker of Ōsaka, has come about because of the dedication and devotion of one person in particular, Don Dame. Not only has he assembled one of the most outstanding collections of prints by Hirosada, he has also been a friend and mentor whose calm and reason were much appreciated as this exhibition became a reality. Guest curator, Roger Keyes, whose diligence and inexhaustable

energy is almost indescribable, has provided much needed insight into the work of this important printmaker which, coupled with the research of Susumu Matsudaira of the Ikeda Bunko Library in Ōsaka, Japan, will serve scholars for years to come. To say "thank you" to each is only a simple token of what is owed.

I also wish to express my appreciation to all of the lenders, individual and institutional, who have made this exhibition possible. No exhibition of this magnitude ever becomes a reality without the generosity and sense of sharing that you all have so selflessly demonstrated. Special recognition is also due to director, Constance W. Glenn, and the staff of The University Art Museum, Roger Keyes' assistant, Pauline Sugino and to Kirsten Jacobs Whalen whose patience with this project has been extraordinary. **Hirosada: Ōsaka Printmaker** was made possible by support from the National Endowment for the Arts, 49er Shops and the CSULB Foundation. In addition the museum has received general operating support during the preparation of this exhibition from the Institute of Museum Services, a Federal agency, and the California Arts Council.

— *Jane K. Bledsoe*

HIROSADA
ŌSAKA PRINT DESIGNER

The work of the nineteenth century Japanese print designer Konishi Hirosada rises from the mists of time like a mountain peak above an ocean of cloud. Only as the mists lift can we start to discern, like an emerging landscape with ridges and valleys, the full extent of his achievement and begin to understand the relationship between his life and his art. Even what we see above the clouds shows us that Hirosada was the most prolific and most influential print designer who worked in the city of Ōsaka in the nineteenth century; he was also perhaps the most serious and accomplished. He seems to have begun his career abruptly in 1847 without antecedents and worked steadily through 1852 producing over eight hundred prints, after which his work suddenly declined, first in quality, then in number, until the last print with a Hirosada signature appeared in 1861. As the clouds of history dissipate, however, a very different picture emerges. We see a precocious youth who attracted the attention of the most influential teachers of print design both in Ōsaka and Edo; an artist who had worked for twenty-five years and established himself both as a leading Ōsaka artist and as an important print publisher before he changed his name to Hirosada in 1847 and made his "debut." At the height of his career, around 1850, we see a modest, mature, retiring man, generous to his friends, who accepted other people's generosity in return, an artist who limited himself by choice to a single subject: portraits of kabuki actors. Within this chosen limitation Hirosada created some of the most brilliantly designed, deeply felt and beautifully produced woodblock prints of the nineteenth century. Then, at the end of 1852 while still in his early or mid-forties when he was at the height of his ability and influence, Hirosada suddenly retired and gave his name to a fourteen year old student and produced no more prints until his death in 1864. But that is jumping ahead, let us start at the very beginning of Hirosada's life and career.

Hirosada was born in Ōsaka around 1810 into a merchant's family with ancestral connections in Kyōto. His family's business name was Kyōmaruya and the artist's personal name was Seijiro.[1] Like many Japanese print designers in the nineteenth century, he was precociously talented. By the age of twelve or thirteen he was invited to join a circle of poets in Ōsaka led by the print designer Jukōdō Yoshikuni. Yoshikuni gave the boy his first art name, Tamikuni, and one of his verses was included on a woodblock print published around the beginning of 1823.[2] In the middle of 1823 Hirosada designed his first woodblock print. Like most prints published in Ōsaka, it was a portrait of kabuki actors in current roles and, like the verse, it was also signed Tamikuni.[3]

At the end of 1823, Tokuraya Shimbei, one of the leading Ōsaka publishers, published Hirosada's first important print, a large close-up portrait of the actor Onoe Tamizō II against a yellow background (catalogue no. 1). Tokuraya specially honored the youth by inscribing the design with a verse he had composed.[4]

Between 1823 and 1826 Hirosada designed at least nine other portraits of kabuki actors.[5] In 1826 he adopted the clan name Toyokawa that belonged to his teacher Yoshikuni and a secondary name, Kōgadō, modeled on his teacher's studio name, Jukōdō. Hirosada was around sixteen at this time and, while he was affirming his tie to his first teacher Yoshikuni, he also seems to have sought an independent identity of his own. At any rate, that year he designed a privately produced actor portrait which he sealed with a new clan name, Konishi, and signed with an entirely new art name, Gochō.[6] This period of Hirosada's life ended when, late in 1826 or early in 1827, the young artist left Ōsaka for Edo to study with Utagawa Kunisada, the most important designer of actor prints in the entire country. Kunisada accepted the boy as a pupil and soon gave him a new art name, Sadahiro.[7]

Hirosada returned to Ōsaka briefly in 1830,[8] but soon afterwards resumed his studies with Kunisada in Edo and there befriended a fellow pupil, Utagawa Sadamasu, the wealthy Ōsaka townsman who later became his patron. The two returned to Ōsaka in the entourage of the actor Ichikawa Ebizō V (Danjūrō VII) in the spring of 1834 and each designed a print for a theater performance in the third month of that year. Hirosada's print was signed Kōgadō Tamikuni,[9] his last reminder to the citizens of Ōsaka that the boy who had left to study in Edo eight years earlier had finally come home. From later in 1834 through the spring of 1841 the prints and book illustrations he designed in Ōsaka were signed Sadahiro.[10]

Hirosada's first book illustrations were for a humorous critique in two volumes of a circle of amateur celebrity artists in Edo. *Nanka's Dream (Ginkei issui nanka no yume)* was written by Hatake (Heitei) Ginkei, another young man Hirosada had befriended in Edo who also seems to have accompanied the artist on his return to Ōsaka. *Nanka's Dream* was published at the beginning of 1835.[11] In the autumn Ginkei and Hirosada collaborated on another book, *Street Gossip (Naniwa zasshi chimata no uwasa* or *Machi no uwasa),*[12] a series of imaginary conversations about life in Ōsaka between two men recently arrived from Edo and an Edo poet who had lived in Ōsaka for several years.

Between 1834 and 1842 Hirosada established himself in Ōsaka as a leading print designer and book illustrator.[13] Most of his single-sheet prints during this period were portraits of kabuki actors, but he also designed a group of landscape views of Ōsaka (figure 1) and a few portraits of female entertainers (catalogue no. 3). Hirosada designed few prints between 1838 and 1840 as Ōsaka slowly recovered from

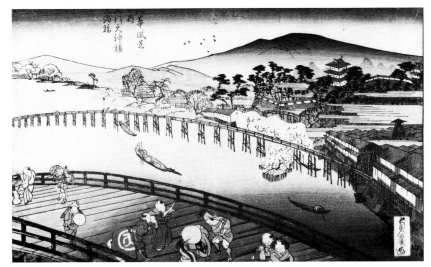

Figure 1. Tenjin Bridge and Temma Bridge on the Ō River. From "Views of Ōsaka," *Naniwa meisho no uchi.* c. 1836. *Ōban* format. Signed, Sadahiro ga. Publisher: Tenki. Collection: Tōru Sekigawa, Kyoto.

the effects of a severe nation-wide famine, food riots and a full-scale rebellion against the government by followers of a samurai named Ōshio Heihachirō.

Most early nineteenth century Ōsaka print designers, even the most accomplished ones, supported themselves by other means. By 1835 Hirosada seems to have joined the firm of Temmaya Kihei, one of the leading Ōsaka print publishers. This association was maintained until his retirement as a print designer at the end of 1852.[14]

The prints that Hirosada designed from time to time between 1834 and the spring of 1841, particularly his portraits of kabuki actors, seem tentative, as though the artist was slowly searching for a personal style. Some of these prints, such as the horizontal view with a perspective background of a scene from *The Revenge at Iga Pass* published in the third month of 1836[15] and his landscapes (catalogue no. 2), were quite different from anything that had been published in

Ōsaka until then but were based on the work of Edo artists that Hirosada had studied during his long apprenticeship with Kunisada. In the actor portraits Hirosada designed at this period he often placed more emphasis on the area around the actor's face than on the rest of the figure or the background of the picture, thus foreshadowing the interest in close-up portraits which he pursued later in his career.[16]

In the fourth month of 1841 Hirosada experienced a sudden burst of creativity and designed six striking prints. All of them displayed a new intensity of vision, a sharp clear focus and each evoked a distinct and different mood.[17] These remarkable new prints mark the beginning of a long, important association between Hirosada and the independently wealthy artist Utagawa Sadamasu. At the beginning of 1840, Sadamasu had begun to design a series of close-up portraits of kabuki actors in the half-block or *chūban* format. Sadamasu probably paid for, or at least subsidized, this publication

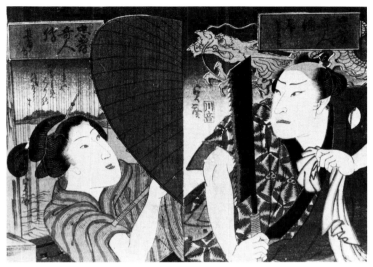

Figure 2. "Examples of Unusual Loyalty and Filial Devotion,"
Chūkō kijinden. Early 1847. *Hosoban* format. Detail. Signed, Sadahiro.
Publisher: Kawaoto. Collection: Haber Collection, New York.

himself since the pictures lack the marks of a commercial
publisher. They were printed in small editions with gold,
silver, embossing, and other expensive technical refine-
ments.[18] Compared to ordinary prints published in Ōsaka at
this time they were colored with a new intensity and drawn
with a bold, new directness.

Sadamasu invited Hirosada to design two prints in
the same style and format for performances in the spring of
1841. These prints (catalogue nos. 5a, 5b) were the artist's first
masterpieces and it is easy to imagine that their success
prompted Hirosada to design the four additional prints
mentioned earlier (see note 17). Hirosada designed at least
eight more single-sheet woodblock prints between the fifth
month of 1841 and the first month of 1842. Six months later
government regulation brought this phase of his career
to an end.

In an effort to stabilize the nation's economy and curb
social unrest the government councillor Mizuno Tadakuni
promulgated a long series of strict sumptuary laws and
ordinances in the early 1840s. Because they were enacted at
the end of the Tempō period (1830–1844), these came to be
known as the Tempō Reforms. A ban on the production and
sale of block-printed actor portraits was announced in Ōsaka
in the seventh month of 1842 and soon afterwards two men
were fined ten thousand *mon* each, a large sum, for selling
actor prints in violation of the ban.[19]

The new laws were extremely unpopular and Mizuno
soon fell from power as a result. The new councillors took few
steps to enforce the regulations but made no move to repeal
them. Because of this uncertainty, print publishers in Ōsaka
did not attempt to publish actor portraits for more than five
years. Finally, Hirosada was the first artist to test the govern-
ment's resolve. In the spring of 1847, after five years of relative

11

inactivity,[20] he designed a small sheet of six historical figures, three men and three women, whose lives embodied the virtues of loyalty and filial devotion (figure 2).[21] The print itself was unprepossessing, but to theatergoers, the unassuming representations of the swordsman Miyamoto Musashi, the feudal lord Oguri Hangan and the sculptor Hidari Jingorō were unmistakable portraits of the kabuki actors Arashi Rikaku II, Kataoka Gadō II and Jitsukawa Ensaburō.

The strength of the townsmen's fear of government punishment in mid-nineteenth century Japan is reflected in Hirosada's next steps in reintroducing actor portraits as an acceptable subject for woodblock prints. Uncertain whether the government had failed to respond to his previous pictures out of oversight or indifference, the artist designed four larger prints of single actors in identifiable roles and signed them with an altogether fictitious name, Hirokuni, and omitted the mark of a publisher.[22] When the government showed no inclination to enforce the ban of 1842, the artist designed another group of prints in the same format on which he announced a change of name from Hirokuni to Hirosada. Hirosada, a simple reversal of the characters in the name Sadahiro, was enough of a subterfuge to allow the well-known artist to deny complicity in case the government chose to prosecute the matter.[23]

When the government took no action, Hirosada realized that the ban on actor portraits was no longer in effect and designed over a dozen portraits of actors who appeared in performances in the seventh month of 1847. Most of these were in the quarter-block format but two were close-up portraits in the *chūban* or half-block format, the predominant form of Hirosada's work for the next two years.

From the middle of 1847 until the beginning of 1849 Hirosada and other print designers of the Ōsaka school maintained the fiction that their actor portraits were actually representations of men and women from history and legend who embodied desirable moral qualities. To affirm their quasi-educational purpose the prints regularly bore titles such as "Tales of Loyalty and Filial Devotion." Series titles were usually placed in the upper right hand corner of the picture within a vertical cartouche, the actor's role was usually identified in another square or geometric cartouche placed beside the title.

The different ways in which Hirosada inscribed role names on actor's portraits often helps to date his prints. From 1847 through the first month of 1849 role names were inscribed in secondary cartouches placed beside the series title at the top of the print. Hirosada used a variety of these cartouches but employed them in succession at specific dates. For example, he used a truncated cartouche with rounded bottom corners only on prints published between the seventh month of 1847 and the third month of 1848 (catalogue nos. 6, 13b). He also used an oblong cartouche derived from the *toshidama*, or "year seal," of his teacher Kunisada only between the fifth and eighth month of 1848 (catalogue nos. 7, 8). Hirosada stopped using elaborate cartouches for role names in the first month of 1849 and for the rest of the year the role names on most of his prints were either omitted or written boldly above the actors' heads (catalogue nos. 9–30). At the beginning of 1850 Hirosada began to inscribe role names on small upright rectangular cartouches. These were sometimes multi-colored (catalogue no. 32), but were usually red. Many prints published during this period also bear abbreviations of the title of the play (catalogue nos. 30, 31, 35). This practice continued until Hirosada's retirement at the end of 1852 and was also adopted by his successor. There are some exceptions to these rules: role names occasionally appear in vertical cartouches on prints published before 1850 (catalogue nos. 14, 21b) and some prints lack role names

altogether (catalogue nos. 39, 40, 51); but, by and large, Hirosada was consistent in his usage.

Actors were not named on prints until around 1858 since block-printed portraits were still, strictly speaking, banned by the government. But the Ōsaka artists, Hirosada in particular, carefully differentiated one actor from another in their portraits and theatergoers could immediately recognize actors by their features. Other indications of actors' identities such as family crests and personal emblems were often incorporated into print designs. A stylized orange blossom, for instance, often appears in portraits of the actor Kataoka Gadō. Sometimes these emblems, which often help identify unfamiliar actors, are bold and conspicuous, sometimes they appear inobtrusively as patterns on a collar, hairpin, sash or hem.

The last portion of Hirosada's career lasted for five and one half years, from the middle of 1847 through the end of 1852. During this period when he designed approximately eight hundred single-sheet prints there were two important changes in the direction of the artist's work that divide his late work into three distinct periods. In the first period, between mid-1847 and the end of 1848, most of Hirosada's prints were paired or multi-panel close-up portraits of kabuki actors in the half-block (chūban) format that Sadamasu had introduced in 1840. In these portraits Hirosada focused on the upper torso of the actor and excluded the rest of his body and any indication of a background setting. The viewer was thus encouraged to visualize the rest of the figure and to imagine the physical and dramatic relationship between the actor in the scene portrayed. Hirosada stimulated the viewer's imagination by introducing incomplete elements or gestures into his design: a sword hilt held at an oblique angle might suggest a duel, the end of a stick in an actor's hand might suggest a lantern and hence, night. Each picture in a set would be the same size but he would indicate closeness, separation, tension or harmony between the characters by adjusting their proportions.

Some actors portrayed in polytychs designed during this period seem physically closer to us than others and some figures seem visually closer to one another. Most Japanese print artists designed multi-panel compositions so that the panels could be viewed either separately or as a single, complex, continuous design. Hirosada refused to do this. Instead, he requires the viewer to focus separately on one figure after another and to jump, rather than to slide, from one panel to the next. This method of looking was perhaps as unfamiliar to the Japanese in the nineteenth century as it is to us today. Since we are accustomed to pictures with visual continuity and habitually scan from one panel to the next, some of Hirosada's polyptychs are disquieting at first glance — separate panels often "make better sense."

Through many formal experiments between mid-1847 and the end of 1848 Hirosada discovered how to capture the viewer's attention: he learned to create a precise placement of the placards of script that bore the name of the series and actors' roles (catalogue no. 7). Like his teacher, Kunisada, he explored the rich textures, colors and patterns of fabrics and observed and recorded the sometimes ironical discrepancies between the personality of an actor and the character he portrayed (catalogue no. 8). Within this short period of twenty months he designed over two hundred prints, five times the number he had designed in the previous quarter century and more than practically any previous artist of the Ōsaka school.

Most of these prints were probably published with a subsidy from Sadamasu who "offered guidance" to a number of Ōsaka artists during this period and used his wealth to influence the course of print production.[24] Hirosada accepted

his friend's guidance and even acknowledged Sadamasu as his teacher on a print published in Edo in the summer of 1852.[25] Prior to 1842 the majority of prints published for commercial distribution in Ōsaka were full-length portraits of kabuki actors in the full block (ōban) format. Since Sadamasu's own taste ran to close-up portraits in the half-block format (see note 18), the sudden publication of over two hundred of these prints to the almost complete exclusion of prints of other types strongly indicates his influence.

In the first month of 1849, a twelve year old actor named Nakamura Tamashichi made his stage debut at the Kado Theater in Ōsaka and Hirosada designed three triptychs for the performance (catalogue nos. 10–12). Hirosada may have identified with the child since he had begun his own career at such an early age and he may have sympathized with him because the boy's father had died two years earlier. Whatever the reasons, designing the prints for Tamashichi's debut led Hirosada into a new unexplored realm of documenting human feeling and marked an important turning point in his career. Until then, many of his prints had been exercises in virtuosity and explorations of technique. Afterward, he placed his formal skills in the service of a new vision: to reveal the emotional depth of the scenes he chose to depict.

His work became simpler, clearer and more direct. As in his work of 1847 and 1848, nearly all the prints he designed in 1849 were close-up portraits of actors in the half-block (chūban) format, but his relation to his subjects and materials changed. He dispensed with series titles and cartouches for role names, the actors' poses became more important than the patterns on their robes, their faces began to reveal nuances of their roles and he began to use color more systematically to create a wide range of moods and emotional effects.

The close-up portraits that Hirosada designed in 1849 were sumptuously printed with embossing, burnishing, gold,

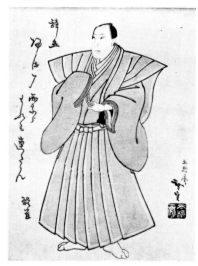

Figure 3. Hasegawa Sadanobu. Memorial portrait of the actor Nakamura Utaemon IV. 2/1852. *Chūban* format. Signature, Sadanobu hitsu. Collection: Philadelphia Museum of Art.

silver, and copper and a variety of other new and unusual pigments. Many of the most outstanding designs are quite rare, known only by one or two fine, early impressions. This suggests that the original editions were small and points to an ongoing subsidy for their publication.

In 1849 two other new aspects of Hirosada's work began to emerge. The first is the publication of deluxe and ordinary editions of the same print. Deluxe impressions using the techniques and pigments described above were costly to produce and, if they were sold commercially, expensive to purchase. Once the blocks were carved, however, cheaper impressions could be printed with fewer embellishments on less costly paper with commoner pigments (substituting yellow for gold, for instance). The publication of editions directed at different audiences became quite common in the 1850s although some examples appeared in 1849 (catalogue no. 25).[27]

14

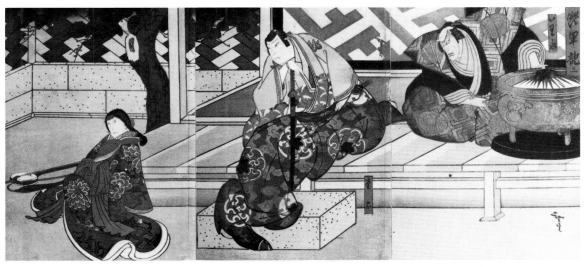

Figure 4. Ichikawa Ebizō V as Iwanaga, Kataoka Gadō II as Shigetada, Ichikawa Danzō VI as Akoya. Titled, *The Helmet Chronicle*, Act 3 *(Kabuto gunki)*. 1/1853. *Chūban* triptych. Signature, Hirosada. Collection: Ikeda Bunko Library, Japan.

In the fourth month of 1849 Hirosada designed his first polyptych in the *chūban* format with full-length figures in a descriptive setting (catalogue no. 23b). In the eighth month he designed his first set of prints with full-length figures illustrating different scenes from a single play (catalogue no. 29). These prints reflect Hirosada's expanded range of expression with which he created an atmosphere or tone that served as a foil to the performance taking place within them. Sometimes the setting matched the mood of the action (catalogue nos. 38, 47, 48), sometimes it contrasted with it (catalogue nos. 31, 37) but it always deepened the viewer's perception, understanding or appreciation of the human drama. For the next two years this type of picture outnumbered his close-up portraits, although he would occasionally produce different versions of the same scene in close-up and full-figure (catalogue nos. 35–36).

Hirosada designed many portraits of Nakamura Utaemon IV between the actor's return to Ōsaka at the end of 1849 and his sudden and unexpected death in the spring of 1852 (catalogue nos. 31, 32, 35–37, 41, 42, 45–52). Hirosada was deeply affected by Utaemon's death, a contemporary portrait shows him weeping with other admirers at the actor's deathbed (figure 3). Soon afterward he interrupted his activity and at the end of the summer travelled with his friend and patron Sadamasu to Edo where Hirosada designed prints for performances in the eighth and tenth months of 1852 (catalogue nos. 55–59).[28] One of the last was a triptych with close-up portraits of Nakayama Nanshi II and Onoe Tamizō II, the actor who had inspired Hirosada's first verse and prints in 1823, against a gold background. In *The Stone Bridge*, Tamizō danced the familiar role of a lion who pushes its child into a ravine to test its strength. The cub successfully struggles up

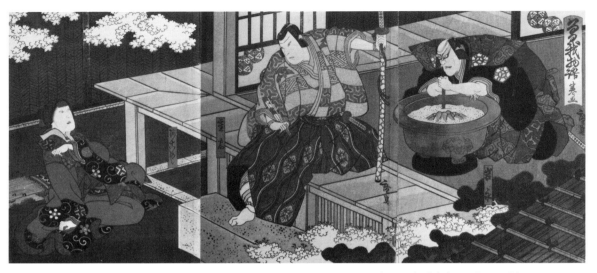

Figure 5. Hirosada II. Ichikawa Ebizō V as Iwanaga, Kataoka Gadō II as Shigetada, Ichikawa Danzō VI in Act 5 of *Keisei soga haru'no fujikane*, Kado Theater, 1/1853. *Chūban* triptych. Signature, Hirosada. Collection: Ikeda Bunko Library, Japan.

the rocky cliff to rejoin the parent and the two dance joyfully together among butterflies and flowers.

At that time, Hirosada had a pupil named Hirokane who was fourteen years old. Perhaps because he was affected by Tamizō's dance he gave the boy his own old name, Sadahiro, and had him design his first commercial prints, quarterblock close-up portraits for the play to be performed at the Kado Theater in the first month of 1853.[29]

At the same time Hirosada had begun to design prints of his own for the New Year performance, and one of these was also engraved and published (figure 4). Then Hirosada decided abruptly, even implusively, to retire altogether from print design and gave his own name to his young student and protégé. In a great flurry of activity, the boy repaid his teacher's confidence by designing fifteen polyptychs with forty-three prints, nineteen of them close-up portraits, for the eight acts of the play. The prints of Hirosada II are very

different from his teacher's. His portraits have less character, he repeats poses in close-up and full-length pictures of the same scene, his backgrounds are filled with more detail and less unified by pattern, his signature is larger and less compact. Comparing the triptych Hirosada II designed for Act Five of the New Year play (figure 5) with his teacher's shows many of their differences. The similarity of their prints results from their working in the same general style and palette, in the same format, with the same group of engravers and printers.

Hirosada II did not maintain this level of activity. In the next two and a half years he designed about the same number of prints he had done for the New Year performance of 1853. In the eighth month of 1861 he designed a vertical diptych of the actor Onoe Tamizō as the priest Mongaku performing penance in a waterfall. In the summer of 1864 Hirosada died. His pupil changed his name a second time and

from the ninth month of that year began designing prints as Sadahiro II.

Hirosada was also close to the Ōsaka print designer Hasegawa Sadanobu. The two were nearly the same age, had both studied in Edo with Utagawa Kunisada[31] and returned to Ōsaka together in 1834.[32] In 1843 the two artists formed a working relationship. Sadanobu was adopted into the family of the publisher Temmaya Kihei[33] and used Hirosada's surname Konishi before his signature on prints in a series of half-length portraits published soon afterward.[34] Difficulties arose and Sadanobu soon left the family. The two artists remained friends, however, and in 1848 and 1849 Sadanobu adapted six of Hirosada's drawings of actors into color woodblock prints.[35] This generosity with his work was typical of Hirosada — his patron Sadamasu also designed a print in 1848 based on one of Hirosada's drawings.[36]

Although Hirosada is principally known for his color woodblock prints and book illustrations (see note 11), he was also an outstanding draftsman. His studies for prints published between the seventh month of 1847 and the eighth month of 1852 (catalogue nos. 6, 55b) are clearly conceived and confidently drawn.[37] In contrast to most drawings by contemporary Edo artists such as Kuniyoshi and Kunisada, Hirosada's drawings are highly finished and most of the costumes and backgrounds are lightly colored. Not all of Hirosada's studies for prints were published; some were replaced by new designs (catalogue no. 27). Although the colors of the prints were deeper and more intense, the designs of published prints were quite close to the drawings in most cases.

Two exceptions are included here because they show Hirosada's imagination and sense of humor: the reversal of position of two close-up portraits (catalogue nos. 55b, 55c) and the expansion of a two-panel design into a three-panel print (figure 6, the two figures at the left in the illustration were not present in Hirosada's original drawing). The emotional tone of Hirosada's prints deepened between 1848 and 1849 as his sense of color and the function of decorative pattern changed and there seems to be a corresponding change in his drawings. The drawings of 1848 and 1849 are equally strong, lucid and assured, but the actors' poses in the later drawings are often more dramatic and poignant.[38] Hirosada's only known painting is a silk hanging scroll with a formal seated portrait of the actor Nakamura Utaemon IV.[39]

The pattern of publication of Hirosada's prints between 1847 and 1852 shows another example of the artist's modesty or lack of self-aggrandizement. Until the Tempō Reforms of 1842 a relatively small number of publishers in Ōsaka commissioned, produced and distributed the work of a relatively large number of artists. During the last period of Hirosada's career this pattern was reversed. A number of artists designed prints but Hirosada probably designed four-fifths or more of the pictures that were published during this five and one half year period. Through his association with the publishing firm Temmaya Kihei, Hirosada was in a strong position to profit from the popularity of his work by having his own firm monopolize the production of his prints. However, he systematically distributed his designs to at least twenty other publishers enabling them to benefit and prosper from the popularity of his work.[40] Ōsaka publishers at this time identified themselves with small seals that were hand-stamped in red ink in the lower corner or lower margin of early impressions of each print.[41] Some of these publishers were engravers and printers,[42] some appeared rarely, some lapsed, others thrived and continued.[43]

During the 1830s and early 1840s Hirosada had designed a variety of seals for his prints. To enhance their appeal many of Hirosada's prints from 1847 on bore red seals

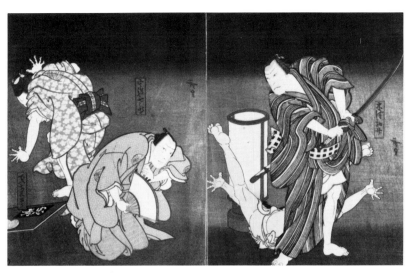

Figure 6. Jitsukawa Ensaburō as Kizu Kansuke, Mimasu Daigorō IV as Ujiya Shichibei, in *Sao no uta kizugawa hakkei*, Naka Theater, 8/1849. Two panels of a *chūban* triptych. Signed, Hirosada. Collection: Ikeda Bunko Library, Japan.

which were hand-stamped beneath his signature when the color printing was finished. Since Hirosada enjoyed variety, each of the main publishers of his work during this period was given a different seal to stamp on their editions of his prints.[44]

Hirosada's prints are an exploration of the depth and meaning of human relationships. They are intimate and direct. Other Japanese artists had portrayed the timeless, fragile and unchanging aspects of human life. Hirosada celebrated the separate, unrepeatable, unique human event. His prints show particular actors in particular roles; each figure is individual, clear and distinct. Tension arises when these figures meet, and the viewer must choose to enter their world or remain outside it. Entering that realm, the viewer begins to experience as his or her own the depth of feeling in the scene and the complexity of the relationship.

A new sense of self might emerge through this experience. For Hirosada's contemporaries, the distinctness of the artist's figures gave viewers a new sense of their own individuality, of the personal self as distinct and separate. The emotions of the figures confirmed the self by mirroring the depth of the viewers' own emotional lives and the reality of their own relationships. The same elements in Hirosada's pictures can remind us today of the reality and importance of our own inner life and recall to us aspects of ourselves that are forgotten, dormant or hidden.

Hirosada's prints embody human qualities that might help us to maintain both our personal equilibrium and the fragile balance of the world. They include clarity, intelligence, humor, stillness, strength, a just sense of human difference, and respect.

— *Roger S. Keyes*

Notes

1. This information and the additional fact that the artist lived in the Namba Shinchi district of Ōsaka was recorded in the early 1840s by Kimura Mokuō (Uyū Sanjin). Kimura's manuscript "Thoughts on Popular Artists in Kyōto and Ōsaka" (*Keisetsu gessakusha kō*) was reprinted in *Zoku enseki jisshu* (1927) vol. 1, pp. 258–283. The note on Hirosada appears on p. 282. Excerpts from the manuscript with biographies of Ōsaka print designers are translated in Keyes and Mizushima (1972), p. 317.

2. Tamikuni's verse appeared on a bust portrait of the actor Onoe Tamizō II designed by Shunchōsai Hokushō soon after the popular young actor's return to Ōsaka in 1823. The verse reads "As its blossoms open, the fame of the cherry tree spreads and it is praised in all quarters" (*Yomo ni na o hirakite homuru sakura kana*). An impression of the print is illustrated in Keyes and Mizushima (1972), plate 28.

3. Tamikuni was written with the character "people." In addition to the verse mentioned above, one print has been recorded with this early signature. It is a double portrait in the *ōban* format of Onoe Fujaku as Gofukuya Jūbei and Ōtani Tomoji as Kumosuke (Numazu no) Heisaku which was published by Shohon'ya Seibei (Honsei) and Senri around the beginning of 1823 (figure 7).

4. Publishers rarely contributed verse to prints and this is the only poem by Tokuraya that is known. This picture was published in the eleventh month of 1823 during the *kaomise* performances at the kabuki theater. Actors would often announce name changes during these performances; and for this important print Hirosada altered his signature, replacing the single character for *tami* with two separate phonetic syllables.

5. Kuroda lists nine prints signed Tamikuni in *Kamigata ichiran* (1929), pp. 315–17, and other pictures are also known.

6. An impression of the print is preserved in the Waseda Theatrical Museum in *Kyota kyakushoku jō*, a forty-two volume scrapbook of prints, drawings and other documents of the Ōsaka kabuki theater said to have been compiled by Yoshino Goun V and Hamamatsu Utakuni in the mid-nineteenth century. The second character in the name Gochō suggests that around this time Hirosada may have studied briefly with the Shijō-style painter Ueda Kōchō whose portrait he included in a frontispiece to the novel, *Street Gossip*, published in 1835 (see below). Hirosada may have also produced this surimono since the sheet bears a second hand-stamped red seal with the name Konishi.

7. No work survives from Hirosada's first period of study in Edo, but Naniwa Sadahiro (Sadahiro of Ōsaka) is listed as the last of eleven pupils of Kunisada on the stone memorial erected in honor of Utagawa Toyokuni I in 1828 at the Myōken Temple in the Yanagishima district of Honjo. The Ōsaka artists Sadafusa and Sadanobu were also listed as Kunisada's pupils. The complete Japanese inscription on the memorial stone is transcribed in Yoshida, *Ukiyoe jiten*, vol. 2, pp. 271–272; the names of eight Ōsaka artists named on the memorial are given in Keyes and Mizushima (1972), p. 315.

8. On this visit he designed a print of Onoe Tamizō II and three other actors in a performance at the Takeda Theater in the fourth month of 1830. He signed this print Gokitei Sadahiro and sealed it Tamikuni; an impression is illustrated in *Ukiyoe taisei*, vol. 11, no. 720.

9. The print was a double portrait of Ichikawa Ebizō and Nakamura Shikan II as Mashiba Hisayoshi and Ishikawa Goemon in a performance of the play *Gosan no kiri* at the Kado Theater. An impression is described in Kuroda, *Kamaigatae ichiran* (1929). Temporary name reversions (as from Sadahiro to Tamikuni) did occur both in the Japanese theater and art worlds. On at least one occasion in the late 1840s after the Tempō Reforms, Hirosada and Sadamasu each reverted to earlier names, perhaps to recall the continuity of their work to viewers. For examples see Keyes and Mizushima (1972), plate 66 and figure 280.

10. Hirosada also used five different secondary names on prints published during this period: Utagawa (1835), Gochōtei (1836–37), Nanakawa (1838), Ukiyo and Gorakutei (1841).

11. Five complete examples of *Nanka's Dream* have been recorded in *Kokusho sōmokuroku*, vol. 6, p. 290–2. Toda describes in detail an example of the first volume in the catalogue of the Ryerson collection, p. 292. The book was reprinted in *Nihon zuihitsu taisei*, series 2, vol. 10. Hirosada also illustrated the following books:
Street Gossip (Naniwa zasshi chimata no uwasa, also known as *Machi no uwasa*), 1835, 4 vols. KSM 5.635.1

A Dream of Ōsaka: A Strange Tale from the Licensed Quarter (Naniwa no yume kakuchū kidan), 1835, 5 vols., KSM 6.272.3, in collaboration with Utagawa Sadayoshi
The Courtesan and the Sano Boat Bridge (Keisei sano no funahashi), 1838, 7 vols. KSM 3.28.4
Revenge at the Weir of Promises (Katakiuchi chikai no shigarami), 1838, 10 vols. KSM 2.157.1
The Courtesan and the Cherry Blossoms at Mt. Aso (Keisei asoyama zakura), 1839/40, 13 vols. KSM 3.23.4
The Courtesan and the Snow View Mountain (Keisei yukimiruyama), 1842, 7 vols. KSM 3.36.1
Heroes of the Suikoden (Shunketsu shintō suikoden), Part 4, 1844, 140 vols. KSM 4.333.2
A Tour of Famous Places in Ōsaka (Ōsaka meisho meguri), 1845, 2 vols. KSM 1.584.4
Twelve Pictures with Verse (Jūnizu kyōka jūnizu), an erotic album, undated (late 1840s?), KSM 4.271.3

12. Toward the end of volume 3, the poet Tsurundo mentions Hirosada in a discussion of print publication in Ōsaka:

> "There's Utagawa Sadahiro, too — the guy who did the illustration for *Street Gossip*. He's just in his twenties, but he's awfully good. You'll be hearing more about him. Take a look at his pictures when they come out."
>
> "Sure I've heard of Sadahiro. He lives in Hoteimachi, doesn't he?"
>
> "You've got it!"

This passage is the only document that mentions Hirosada's age. The phrase "just in his twenties" (*hatachi bakari*) suggests that he was closer to twenty than thirty in 1835 when *Street Gossip* was published. The complete passage is printed in *Naniwa sōsho*, vol. 14, p. 282, and a full translation is given in Keyes and Mizushima (1972), p. 316. Eighteen examples of the book are listed in KSM 5.635.1; a two-volume holograph is in the Iwase Library.

13. During this period he illustrated seven books and designed more than forty single-sheet woodblock prints.

14. The main source for the history of Temmaya Kihei is the official district register of landlords and rental properties in the Kikuyamachi district of Ōsaka (*Iemori kashiya shūshi nimbetsuchō minamigumi kikuyamachi*), a document preserved in the Ōsaka Prefectural Library. Apart from its publishing activities, the Temmaya family managed several rental properties (eight of them in

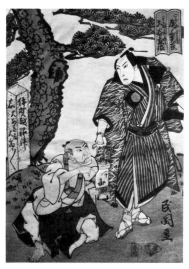

***Figure 7**. Onoe Fujaku as Gofukuya Jūbei and Ōtani Tomoji as Kumosuke Heisaku. 1823. Ōban format. Signed, Tamikuni ga. Publishers: Honsei and Senri. Private Collection.*

1818). As part of the system of government urban surveillance in the nineteenth century, landlords were required to report the names of their renters and changes in the compositions of their own households. Thus we know that Shōkichi, the young man who had been adopted into the Temmaya family as a son and heir in 1824, left the household and returned to his own family after the death of his father in 1834, the year Hirosada returned to Ōsaka. From dated prints we know that outsiders were associated with the Temmaya publishing business from time to time. For example, in 1830 when the business was located on Mitsuderasuji a man named Kishimoto was associated with the firm. This man was neither a direct family member nor a renter, as his name does not appear in the district register. Likewise, from prints we know that the business moved to new premises on Hachimansuji in 1834. Another print dated 1835 records a new name for the firm: Tenki (an abbreviation for Temmaya Kihei) Kinkadō Konishi. Konishi was a name Hirosada had used in 1826 (see note 6), and it appears repeatedly on seals he used on prints published between 1847 and 1852. Hirosada also used the name Gochō as a signature and on seals in 1826 and between 1847 and 1852. One of these seals, which Hirosada used on prints published in 1850 (catalogue no. 31) appeared beneath the name of

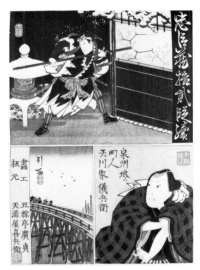

Figure 8. Acts 10–12 from "Twelve Acts of *Chūshingura*" (*Chūshingura jūnidan tsuzuki*). 3/1848. Ōban format. Signed Gakō Gosōtei Hirosada. Publisher: Hammoto Temmaya Kihei. Seal, Gochō. Collection: Ikeda Bunko Library, Japan.

the publishing firm on a print issued two years earlier (figure 8). Hirosada, like Kishimoto, was neither adopted into the Temmaya family nor lived in one of their rental properties, so his name does not appear in the district register. Since his family name and seals appear on prints, he may have managed or supervised Temmaya's publishing activities, but his exact standing in the business is still unknown. However, there seems little doubt that between 1835 and 1852 he was intimately associated with the firm.

15. Two impressions of this print have been recorded, one in the Museum of Fine Arts, Boston, the other in a private collection.

16. In the diptych of two actors as birds published in 1837 (figure 9), the artist's interest is entirely focused on the portrait heads, their position in relation to the drapery and the empty areas surrounding them. The rest of the sheet is rather dull by comparison, unlike the similar triptych published in 1849 (catalogue no. 11) in which the artist's interest extends to the entire design.

17. Four of these were full-length figures of actors in the large *ōban* format: portraits of Kataoka Gadō II as Terakoya Genzō standing by a river in the moonlight (Keyes and Mizushima [1972],

figure 275); Sawamura Gennosuke as Goshaku Somegorō (Ikeda Bunko Library); Nakamura Utaemon III as the courtier Fujiwara Shihei seated on the steps of the imperial palace (Victoria and Albert Museum); and a portrait of Onoe Baikō III as the ghost of the courtesan Usugumo (catalogue no. 4). Two were close-up portraits of actors (catalogue no. 5).

18. The size of editions was not recorded during this period. However, all the known impressions of prints from this group are fine and early, suggesting that printing stopped after a small number of impressions before wear began to show on the blocks. An illustrated checklist of eleven prints by Sadamasu and one by Hirosada in this group was recently included in an article by Jan van Doesburg entitled "New Aspects in the Field of Ōsaka *Chūban* prints," *Andon*, No. 10, Society for Japanese Arts and Crafts, The Hague, 1983.

19. This incident is recorded in *Conditions in the Floating World* (*Ukiyoe no arisama*), a manuscript journal compiled from 1846 on. The passage is quoted in *Kabuki nempyō*, vol. 6 (1961), p. 454–5, after the full text of the government order banning color woodblock prints of actors, courtesans and geisha.

20. Little is known about Hirosada's activities during this period. Kimura Mokuō writing before 1844 (see note 1), mentions that he lived in the Namba Shinchi district of Ōsaka, south of Dotombori theater quarter. *Famous Merchants and Craftsmen of Ōsaka* (*Ōsaka shōkō meika shū*), a printed directory published in 1846 states that Hirosada then lived near the intersection of Mitsudera-suji and Tatamiyamachi on the northern edge of the Shimanouchi entertainment quarter. The premises of the publisher Temmaya Kihei were located two blocks to the west at this time, near the intersection of Hachimansuji and Shinsai Bridge. This document, preserved in the Ōsaka Prefectural Library, mentions two other print designers: Utagawa Sadamasu and Hasegawa Sasanobu. It is quoted in Kuroda, *Kamigatae ichiran* (1929), p. 316. One print Hirosada designed during this period was an alphabet sheet for children (Keyes and Mizushima [1972], no. 279).

21. None of the represented roles were actually performed in 1847. Hirosada copied the figure of the woman with the umbrella in the lower left corner from a print by Kuniyoshi which was published in Edo around 1845 or 1846. An impression is illustrated in an auction catalogue published by Sotheby Parke Bernet, Inc., London,

Figure 9. Nakayama Nanshi II and Arashi Sangorō III as the spirits of two mandarin ducks in *Keisei imose no oshidori*, Wakadayū Theater, 1/1837. *Ōban* diptych. Signed, Gochōtei Sadahiro. Publisher: Tenki. Collection: Museum of Fine Arts, Boston.

28 October 1981, no. 114. The series title he adopted was an abbreviation of the series title on Kuniyoshi's print. The print is signed Sadahiro, but the form of the two characters is identical to those on prints signed Hirosada which were published between mid-1847 and 1852.

22. The four pictures signed Hirokuni were printed on one *ōban* block and then divided. Each bears the name of the subject in a series of "Flowers, Birds, Wind and Moon" and the name of the actor's role. As in the earlier print, none of the roles were performed in 1847. A complete set is in the Ikeda Bunko Library:

Flower	Kataoka Gadō II as Oguri Hangan
Bird	Arashi Rikaku II as Jihizō
Wind	Mimasu Daigorō IV as the fisherman Namishichi
Moon	Jitsukawa Ensaburō as Nagoya Sanza

23. The two quarter-block prints on which Hirosada announced this fictitious name change are portraits of Jitsukawa Ensaburō and Kataoka Ichizō in the roles of Fukuoka Mitsugi and the cook Kisuke which were currently performed at the Takeda Theater in the fifth month of 1847. Impressions of both pictures are in the Ikeda Bunko Library. The series title *Sewa suikoden no uchi* suggested that the heroes in Japanese domestic plays depicted in the prints were analogous to characters in the popular Chinese novel *Shui hu chuan* (pronounced in Japanese *Suikoden*). The Ōsaka publisher Kawaoto took an even greater risk than the artist by printing his firm's name on the portrait of Ensaburō.

24. A short biography of Sadamasu was written by the historian Sekine Shisei around the beginning of the Meiji period (1868–1912). Shisei's son Kinshirō included it in *Honchō ukiyoe gajinden*, a compilation of biographies published in 1899. Sekine states that Sadamasu, "a wealthy householder in the Semba district of Ōsaka, studied with Kunisada and designed a number of actor portraits. Receiving no particular recognition for this, he used his wealth to create a school of his own. He offered guidance to Ōsaka ukiyoe artists and had a great number of pupils. Even today, Ōsaka artists who design actor portraits work in Sadamasu's style." Sekine names a few of Sadamasu's pupils including Hirosada (Sadahiro) whom he identifies as a pawnbroker living in the Kasayamachi district of Osaka. This may be a mistake (the secondary name he gives for the artist, Ippyōtei, was used by another artist, Yoshinobu).

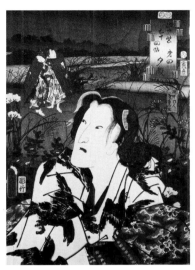

Figure 10. Utagawa Kunisada and Hirosada. Yūgao. No. 4 from "Fifty-four Chapters of Edo Purple" (*Edo murasaki gojūyonchō*). 8/1852. *Ōban* format. Signed, Toyokuni ga; Kunimasu *monjin* Hirosada. Publisher: Moriya Jihei. Collection: Victoria and Albert Museum, London.

25. Hirosada and Sadamasu travelled to Edo together soon after the death of the kabuki actor Nakamura Utaemon IV in the second month of 1852. While there, they visited their old teacher Kunisada who was then in his mid-sixties. Kunisada was preparing for publication a series of half-length portraits of kabuki actors with backgrounds drawn by his pupils and he invited his two former students to participate. The series was based on the *Tale of Genji* and entitled "Fifty-four Chapters of Edo Purple" (*Edo murasaki gojūyon-chō*). Hirosada drew the background for the print illustrating Chapter 4, *Yūgao* (figure 10). Hirosada studied with Kunisada longer, and from an earlier date, than he did with Sadamasu but felt so deeply indebted to his friend that he signed his contribution to Kunisada's set as "Kunimasu's pupil Hirosada." (Sadamasu had changed his artname to Kunimasu in 1844). An impression of the print is in the Victoria and Albert Museum.

26. Sadamasu designed a few half-length portraits of actors in the late 1840s and early 1850s with a distinctly personal style but they were never particularly numerous or popular. For illustrations see Keyes and Mizushima (1972), plate 61, figure 280.

27. A few pictures originally published in 1847 and 1848 are also known in both deluxe and ordinary impressions (catalogue no. 6). These may have been issued later (in the early 1850s) after Hirosada had become more popular.

28. Hirosada II (1838–1908), the son of Tsurusawa Matakichi, a famous samisen player, was born in the Shimanouchi entertainment district of Ōsaka. His personal name was Mitani Matasaburō and he lived near Naka Bridge on Mitsuderasuji, the same district as Hirosada. He first studied painting with the Shijō school artist Yabu Chōsui and then studied print design with Hirosada. He is said to have first used the name Hirokane but his earliest dated works, a pair of quarter-block close-up portraits of actors in a performance in the first month of 1853, are signed Sadahiro. These prints were probably designed in advance of the performance since he redrew them in half-block format and they were issued again in the spring of 1853. The artist used the name Hirosada II until his teacher's death in 1864, then took the name Shōkōtei Sadahiro II. He designed many actor prints and painted theater billboards. In 1881 he joined the staff of the Ōsaka Asahi Newspaper as an illustrator. A short biography by Yukawa Shōdō published in *Kamigata*, vol. 183 (1942) was synopsized by Susumu Matsudaira in *Genshoku ukiyoe daihyakka jiten*, vol. 2 (1982), p. 118.

29. Two of these prints, portraits of Kataoka Gadō II and Nakamura Daikichi III in the roles of Soga no Jūrō and his lover Ōiso no Tora, were engraved and printed in advance of the perform-ance. Examples are in the collection of Peter Morse, Honolulu, who has four more quarter-block portraits also signed Sadahiro of actors in roles performed in the third month of 1853.

30. An impression is illustrated in Matsudaira, *Kamigata ukiyoe 200 nen ten*, 1975, plate 219.

31. Hirosada, Sadanobu and Sadafusa were the three Ōsaka artists listed as pupils of Kunisada on the memorial erected for Utagawa Toyokuni in 1828 (see note 7). Previously Sadanobu had received the art name Yūchō from the Ōsaka painter Ueda Kōchō. He and Hirosada may have been co-pupils of Kōchō since Hirosada used the name Gochō on a print published in 1826 (see note 6).

32. Sadanobu's first single-sheet prints are actor portraits published in 1834. One of these acknowledges Hirosada's friend Utagawa Sadamasu as a teacher.

33. This information was recorded in the Kikuyamachi district register (see note 14). The entry for 1843 states that Tokubei, the son of Naraya Jisuke of Andōjimachi, 3-chōme, was adopted into the Temmaya family and changed his personal name to Senzō. Soon afterward his name was removed from the register. A young woman named Tane was also adopted into the family in the third month of 1844 and changed her name to Taka, but she left three months later.

34. Cited in Keyes and Mizushima (1972) p. 239.

35. Three Hirosada drawings and examples of the Sadanobu woodblock prints based on them are illustrated in Keyes and Mizushima (1972), plate 69. Three other Sadanobu prints based on Hirosada drawings have been recorded: see Keyes and Mizushima (1972) nos. 137.8ab, 137.19c.

36. This was a portrait of Jitsukawa Ensaburō as Miyagi Asojirō. The drawing is in the collection of the Philadelphia Museum of Art (Keyes and Mizushima [1972] no. 137.6b).

37. Two albums with ninety-four colored brush drawings for prints in the half-block format are in the collection of the Philadelphia Museum of Art (Keyes and Mizushima [1972], nos. 136–137). Eighty-eight of them are close-up portraits of actors. No other Hirosada drawings are presently known.

38. Three early and twenty-nine later drawings are illustrated in Keyes and Mizushima (1972), plates 68, 69.

39. The painting is owned by the Nakamura family. It was exhibited at the Kabuki-za Theater in Tokyo in 1967 when the actor Nakamura Fukusuke changed his name to Nakamura Shikan VII.

40. The publishers of Hirosada's work during this period included Daijin, Gen (Suri Gen), Horio (Saiku Horio), Iida (Surikō Iida), Ikekichi, Fujii, Isekichi, Kashimadō, Kawaoto, Kawashin, Kinkōdō, Kita Kagawa, Kyō Isa, Matsuki, Meikōdō, Ningyō Ichi, Temmaya Kihei (Kinkadō, Konishi, Tenki, Ten), Suri Kame, Tsutakan, Uchida Torazō (Uchitora) and Ueda. Of these firms, only Tenki had been active before the government banned the publication of actor prints in 1842. The only other Ōsaka publishing firm that survived the ban on actor prints was Wataya Kihei. Wataki was an old rival of Tenki who prospered in the second half of the nineteenth century but never published Hirosada's prints.

41. The name or emblem of the publisher of a commercial print produced in Ōsaka before the Tempō Reforms was engraved on the key block and appeared on each impression of the print unless it was removed. Privately commissioned prints were often produced by the same publishers but their names or emblems were stamped by hand in red ink on each impression. Hirosada's prints were offered for sale, but they were made with luxurious materials and the superlative craftsmanship that previously had been restricted to private publications. The red hand-stamped seals are a reminder of this. Later impressions of Hirosada's prints often bear seals stamped in black instead of red or omitted the seals altogether. Early and late impressions sometimes bear the seals of different publishers. Occasionally two seals appear together on a print. In these cases, the second, for example the character "Kichi" in a double overlapping square, may be the seal of a secondary retailer or distributor.

42. Uchida Torazō, for example, who engraved a set of prints published by Hirosada's firm Kinkadō in 1848 (catalogue no. 7) also published prints. Horio and Ningyō Ichi were also engravers and Gen, Iida, Kame and Kyō Isa were printers each of whom also published prints.

43. Daijin, Iida, Ikekichi, Kawaoto, Kita Kagawa, and Tenki were mentioned as publishers in "Reminiscences of Bookshops" (*Ezōshiten no tsuioku*) by Hasegawa Sadanobu II, *Anona*, vol. 7, 1929.

44. These publishers used the following seals after Hirosada's signature. These would usually appear in the lower corner or margin of the print.

Daijin	Han Sada (Published by [Hiro]sada)
Kawaoto	Rankei
Kawashin	Mitani (?)
Kinkodo	Sada
Ikekichi	Kinsekidō
Isekichi	Sada han (Published by [Hiro]sada)
Meikodo	Ko
Tenki	Konishi Gochō on prints sealed Kinkadō, Gochō on prints sealed Tenki

Hirosada used approximately seven more seals after his signature. These were associated with four other publishers and on unmarked prints included a small seal reading *Chō* after verses, a square seal reading Gosōtei on a memorial portrait of Nakamura Utaemon IV published in the second month of 1852 (Keyes and Mizushima plate

Figure 11. Nakayama Nanshi II addressing the audience (detail).
c. 1/1850. *Chūban* format. Signed, Hirosada. Seal, Sadahiro.
Collection: Donald Dame, Long Beach, California.

73) and a seal reading Sadahiro on a print published around
1850 (figure 11). This last seal is conclusive proof that Sadahiro and
Hirosada were the same artist. The words "Published by [Hiro]sada"
on two seals suggest that at least some of Hirosada's prints may have
been capitalized by Tenki possibly with subsidies from Hirosada's
patron Sadamasu. It is possible that the co-publishers also made
profit-sharing arrangements.

KABUKI THEATER IN ŌSAKA AND THE TEMPŌ REFORMS

Konishi Hirosada lived and worked in the prosperous mercantile city of Ōsaka. Most of the woodblock prints that were produced in Japan during the Tokugawa period (1600–1868) and the Meiji period (1868–1912) were published in Edo (Tokyo), the nation's capital. However, in the nineteenth century an important school of printmaking which specialized in portraits of actors in the popular kabuki theater developed in Ōsaka. Nearly all of Hirosada's prints were pictures of actors in real or imagined stage roles.

Because of this chosen limitation of subject matter a series of government proclamations that were announced in the early 1840s and known collectively as the Tempō Reforms became one of the most important events in the history of Ōsaka printmaking. Among these proclamations was one which forbade the publication and sale of block-printed portraits of kabuki actors. The new law was strictly enforced and for five years between 1842 and 1847 the production of woodblock prints in Ōsaka practically ceased.

Print publication cautiously resumed in 1847 but the whole world of print publication had changed and the new prints were very different from the old ones. Before 1842 the majority of Ōsaka prints were full-length portraits printed on sheets of paper in the *ōban* format (approximately 15″ x 10″). In 1847, most of them were close-up portraits in the *chūban*, or half-block, format (approximately 10″ x 7½″). Many publishers were active in Ōsaka before and after the Tempō Reforms but only two survived the Reforms and worked in both periods. The majority of the artists who designed prints after 1847 were also new. In addition to the change in size, the artists working in the new style also employed rich colors and elaborate printing which mirrored the gorgeous opulence of the Ōsaka kabuki theater during this period: the quality called *keren*. Hirosada was one of the few Ōsaka artists whose career spanned both periods. Since he used different signa-

tures and the style of his early and late prints is very different, this fact has only recently been established.

In Ōsaka there were three kinds of theaters: *ō-shibai* (big theater), *chū-shibai* (middle theater), which was also known as *hama-shibai* (riverside theater) and *kodomo-shibai* (children's theater). In contrast, the Edo theater world consisted of *ō-shibai* (big theater) and *kō-shibai* (small theater). Actors who are depicted in Edo prints all belonged to the big theaters: Nakamura, Ichimura, and Morita. Actors of the small theater were scorned by big theater actors and the two were completely segregated.

An Ōsaka actor's training began in the children's theater. Upon reaching late adolescence an actor moved on to the middle theater, or, in the case of exceptional actors, to the big theater. If a big theater actor's popularity waned, he would drop back to the middle theater for retraining. Naka and Kado were representative big theaters, Ōnishi (Chikugo) was considered to be both big and middle, Wakadayū, Takeda and Kadomaru were middle theaters.

The middle theater was enthusiastically supported by kabuki fans and was known for its good actors. Actors moved back and forth between the big and middle theaters since the salaries in both did not differ much. For example, Bandō Jūtarō and Onoe Tamizō frequently went back and forth, and Nakayama Tatezō, a very popular actor, performed in the big theater, but soon chose to return to the middle theater on a permanent basis.

The middle theater of Ōsaka was also known for its schooling system and during the late Tokugawa period many Edo actors received training there. The career of Ichikawa Kodanji (1812–1866) is a typical example of an Edo actor who was deeply influenced by Ōsaka's theaters and actors. As a young boy Kodanji left Edo with his father and from the age of eleven he performed in the children's theater of Ōsaka. At the age of seventeen he appeared in the middle theater and at the age of thirty-two he made his big theater debut at the Kado Theater. In 1847, at the age of thirty-six, he made his first appearance at the Ichimura Theater in Edo and later went on to become a great kabuki star renowned for his roles in plays by Kawatake Mokuami.

By the Kaei-Ansei eras (1848–59) kabuki theater in Ōsaka had reached its maturation and no more important new plays were being produced. In a manner similar to an opera company in the west, a repertory of plays was repeated with only minor occasional changes. Importance was placed on the quality called *keren* which was reflected in an actor's fine, detailed and highly dramatic performance, quick costume changes and acrobatics and the colorful and gorgeous stage settings.

In the period before the government's reforms in the 1840s Utaemon III and Arashi Rikan II enjoyed great popularity on the Ōsaka stage. The other important veteran actors were Sawamura Kunitarō, Asao Gakujūrō, Kataoka Nizaemon, Bandō Jūtarō, Onoe Tamizō and Ichikawa Danzō. Most of these actors died before the reforms went into effect. During the period of the reforms Nakamura Tomijūrō and Nakayama Nanshi were both specialists in *onnagata* (female) roles. At the time Nanshi was the only actor active in Ōsaka who was over fifty years old. Mimasu Daigorō, Kataoka Ichizō and Once Tamizō were in their forties and other actors such as Jitsukawa Ensaburō, Arashi Rikaku II, Nakamura Shikan III, Arashi Tokusaburō III, Kataoka Gadō II, Arashi Kichisaburō III and Ichikawa Ebijūrō IV were all in their thirties. With the ending of the reforms, the leading kabuki performers during the Kaei-Ansei eras (1848–59) consisted of these young actors and Ichikawa Danjūrō VII.

The number of published prints featuring an actor is one indication of his popularity. Based on my personal

observation, the actor who appears most frequently is Jitsukawa Ensaburō. He is followed, in descending order, by Gadō, Danjūrō, Rikaku, Daigorō, Rikan, Ichizō, Nanshi and Ebijūrō.

Jitsukawa Ensaburō (1813–1867) started his career in the children's theater and became a pupil of Gakujūrō under the name Asao Ensaburō. In 1833 after training in the middle theater, he became the adopted son of his teacher and changed his name to Jitsukawa Ensaburō. From 1839 he appeared in the big theater and was very well received. Handsome and eloquent, Ensaburō had elegance and dignity, qualities that served him well when he played the role of a young prince. He was better at domestic plays than historical ones. A faithful believer of the Nichiren sect of Buddhism, he performed the role of St. Nichiren to great acclaim. He became Gakujūrō II in 1866 but lost his eyesight and died in 1867 at the age of fifty-five.

Kataoka Gadō II (1810–1963) was Nizaemon VII's adopted son and was originally named Gatō. He began his career in the children's theater and advanced to the middle theater. When his adopted father died he took the name Gadō and moved to the big theater. Although he was short, he was attractive, and together with Ensaburō he was praised as a top actor. He was especially good at Ōsaka domestic plays and dances. He stayed in Edo from 1854 to 1862 where, in 1857, he became Nizaemon VIII. Soon after returning to Ōsaka in 1862 he fell ill and died at the age of fifty-four.

Arashi Rikaku II (1812–1864) was born into a family that operated a theater teahouse. He became a pupil of Rikan and at the age of twenty appeared in the big theater under the name Rikaku. Although his appearance and voice were lacking he could perform any role and was praised as a "clever actor." In 1862 he went insane and left the stage. He died at the age of fifty-three in 1864.

Mimasu Daigorō IV (1798–1859) was the son of Daigorō III. His previous name was Mimasu Gennosuke. After training in the middle theater he went to Edo. In 1837 he returned to Ōsaka and in 1844 he assumed the name Daigorō. Tall and handsome, he acted with great dignity and was especially good at roles in historical plays.

Arashi Rikan III (1812–1863), the son of a travelling actor, became the adopted son of Rikan II. After staying in the middle theater for a while, he moved to the big theater in 1839. A skilled actor of female roles, he played male roles as well. He was very fat but had a beautiful voice.

Kataoka Ichizō I (1792–1862) was the son of Fujikawa Kanekurō, a well-known actor of villainous roles. Trained in Ōsaka's middle theater, he went to Edo and became a success. In 1840 he returned to Ōsaka and was praised as "the great master of evil roles." Tall and eloquent, he was especially noted for his portrayals of villains in domestic plays.

Nakayama Nanshi (1790–1858) was a star of the middle theater who moved to the big theater in 1827. Although he was rather unattractive, he was a great veteran of female roles and, even at age sixty, was adept in the role of a maiden. He retired in 1859 and opened a hair oil shop but died the following year at the age of sixty-nine.

The actors mentioned above were all deceased before the beginning of the Meiji period in 1868. Only Onoe Tamizō II (1799–1886) lived until Meiji 19 when he died at age eighty-seven. He was the son of a theater hairdresser and a star of the middle theater until 1821 when he appeared in the big theater. However, he continually moved back and forth between the two. He was pudgy and reputedly illiterate but his acting was very flamboyant and appealing to audiences. He was skilled at any kind of role and during the Meiji period was the oldest actor in Tokyo and the Ōsaka-Kyōto area.

Ichikawa Danjūrō VII (1791–1859) was a star of the Edo stage who moved to the Kado Theater in 1843 at the age of fifty-four after he was banished from Edo. He lived in Ōsaka until his death at sixty-nine. Although he was allowed to return to Edo in 1847, after three years he returned to Ōsaka. He is thought to have been the leader of a group of young Ōsaka actors. Active and aggressive, he performed various roles in both the big and middle theaters and mastered the roles, primarily of *gidayū* plays, once played by Utaemon III. He also gave his support to the children's theater. He toured the cities of Sakai and Kyōto with the actor Nakamura Tomijūrō and also visited Hyōgo and Ise.

Like Ichikawa Danjūrō VII, Nakamura Tomijūrō II (1784–1855), was a scapegoat of the government and banished in 1843 for his luxurious life style and stage costumes. He was an excellent actor of female roles and a veteran of the Ōsaka and Kyōto kabuki stage. After leaving Ōsaka he established a base in the city of Sakai and toured Kyōto and nearby towns. People from Ōsaka often made one-day trips to Sakai just to see him perform. Tomijūrō was never allowed to return to Ōsaka. He performed in Edo in 1853–54 and died in 1855 at the age of seventy.

During the Tempō era Mizuno Tadakuni, chief councilor of state, promulgated a series of severe governmental measures known as the Tempō Reforms. The purpose of the reforms was to control and boost the economy by means of enforced austerity throughout various levels of society. As a return to older customs and values, the reforms constituted a type of restoration movement. "Simplicity and economy," watchwords of the movement, did not represent new concepts. They had been the standard policy of the Tokugawa government but under Mizuno the reforms had very severe and far-reaching effects.

The capital city of Edo was the first to feel the impact of the reforms: in the first month of 1842 kabuki theaters in Edo were forced to relocate from the center of town to an outlying area. In the sixth month *nishiki-e* (polychrome prints) and books illustrated with colors were forbidden and in the same month the kabuki actor Ichikawa Danjūrō VII was banished from Edo.

In Ōsaka the Reformation started two months later. The delay was due to the method of announcing government policies by way of a public announcement and the posting of notices in the local government office which was used during this period. Known as *ofure*, the announcements in Edo and those in the Ōsaka-Kyōto area had basically the same content but often differed in details and the date of issue.

The merchant city of Ōsaka had a very different atmosphere from the capital city of Edo, the home of samurai and the shogun. Comparatively speaking, the people of Ōsaka were freer, more extravagant and enjoyed life more openly. They cared more about real life than about honor. Governors who were sent from Edo to Ōsaka, much to their dismay as administrators, were faced with these differences in temperament.

One of the early orders of the Tempō Reformation attacked the "twenty-five bad customs in Ōsaka" by prohibiting the following: large decorations for festivals, extravagant fireworks, decorative gifts for shop openings, luxurious home interior decorations, gaudy sign boards, unseasonable flowers and plants, expensive children's toys, the study of martial arts, mixed public baths and public chanting of ballads (*jōruri*) in front of residences. Daily life was restricted in many other ways. For example, expensive cakes, luxurious decorations and dolls for the Children's Festival, extravagant cooking, decorations on smoking pipes, gatherings in shrines and temples, boating parties, expensive Nō costumes, keeping of

rare birds and plants, tattoos and gambling were forbidden. There were restrictions on every detail of clothing, hair ornaments and footwear. Townsmen were forbidden from keeping gold and silver receptacles and forced to turn them in to the authorities. Female hairdressers for women were labeled an extravagance and banned except for professional entertainers such as geisha and courtesans.

Regulations centering on two controversial institutions — the licensed quarters and the theater — were especially severe. The government would have abolished these places if it were possible. Instead, they tried to segregate those employed there by treating them as members of the lowest class. For example, people working in teahouses and baths were ordered to change their occupations or move to Shinmachi, the licensed quarters. At the entrance to Shinmachi patrons had to sign their names under the gaze of a watchman. All people working in Shinmachi, even merchants, were required to wear *amigasa*, large hats that concealed their faces, whenever they left the quarters. Inhumane treatment was extended to prostitutes. According to *The Situation of the Floating World (Ukiyoe no arisama)*, a detailed record of Ōsaka and Kyōto written by an unknown doctor who lived in Ōsaka, neither coffins nor funeral ceremonies were allowed for prostitutes: when they died their legs and arms were tied together and they were carried away on a pole like animals.

In Ōsaka only five theaters in the Dōtonbori district were allowed to operate: Kado, Naka, Wakadayū, Takeda, and Chikugo (Ōnishi). When kabuki was not being performed puppet shows were staged and tours of provincial towns by actors of the three main cities were banned. A ceiling was put on salaries of actors and they were forbidden to mix with the general public. In Ōsaka the regulations were probably designed to suppress the fan clubs of kabuki actors,

organizations with a long tradition and the solid backing of rich merchants.

Oppression of theater workers was also very harsh. When the Temma, Kita-shinchi and Horie Theaters were forced to shut down, three hundred workers lost their livelihood. When the workers went to the local government office to beg for permission to reopen the theaters, the answer they received was, "the entire nation is suffering under reforms. How important are a mere three hundred people?" In another instance in 1842 on the 15th day of the 7th month, *jōruri* narrators, puppeteers and kabuki actors were summoned to the west Ōsaka government office to hear strict orders. The two top-ranking narrators were allowed to sit on a low platform, other narrators sat on a plain mat, puppeteers on a rough straw mat and actors on the rocky ground. When all were seated they were referred to as "the river-bed beggers," a term usually reserved for animals.

Showy costumes of narrators and puppeteers were also forbidden, as were gorgeous stage decorations. Like kabuki actors, narrators and puppeteers were forced to live in the Dōtonbori district and all of them were ordered to wear *amigasa* whenever they went out.

Trade was also subject to many restrictions as well. The government dissolved *kabu-nakama* (guilds) which were believed to cause inflation, ordered the lowering of prices and set maximum prices for goods and required that every townsman make substantial donations to the authorities, a hardship that drove some people to commit suicide.

In 1842 governmental suppression of publications went into effect in Edo. Nearly two months later the same order was issued in Ōsaka. According to these orders the following were forbidden: prints of kabuki actors, courtesans and geisha, publications illustrated with actor portraits, publications using stories and ideas of kabuki plays and color

illustrations on book covers and wrappers. *Kabuki hyōbanki* (kabuki critiques), though not singled out by the orders, were also affected and publication temporarily ceased. The government encouraged publications for children that would promote loyalty, filial piety and sincerity. Under these restrictions no color drawings of actors on fans or candies were allowed. As a result actor prints in Ōsaka vanished for five years.

In 1843 Mizuno was dismissed from his position as councillor of state. The immediate cause of his fall from power was his highly unpopular plan known as *Jōchirei* which was designed to put all lands near Edo and Ōsaka under the control of the government. Even without the uproar over *Jōchirei*, Mizuno would have probably been ousted for his harsh reforms that had brought economic confusion, depression and widespread unemployment to the country. Although Mizuno was no longer in power, the government made no attempt to rescind the orders of the past three years. In 1844 and 1845 the government in Ōsaka repeated its intention to uphold the spirit of the reforms. Nevertheless, a gradual loosening occurred and although there was no official permission to restore *nishiki-e* (polychrome prints), printmakers cautiously resumed production in 1847. By the Kaei-Ansei eras (1848–59) a powerful revival of the kabuki theater was underway and it is the richness of this revived theater that is reflected in the marvelous actor prints of Hirosada.

— **Susumu Matsudaira**
text adapted by Pauline Sugino

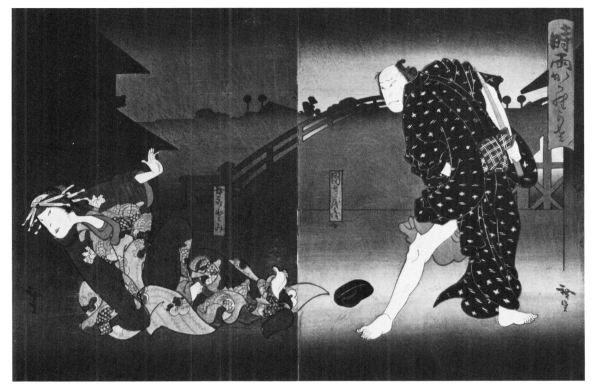

Number 48
Nakamura Utaemon IV as Danshichi Mohei
Nakayama Nanshi II as Tomi
in *Yadonashi danshichi shigure no karakasa*, "Homeless
 Danshichi: An Umbrella in the Rain," Naka Theater
Chūban diptych
Collection: Donald Dame, Long Beach, California

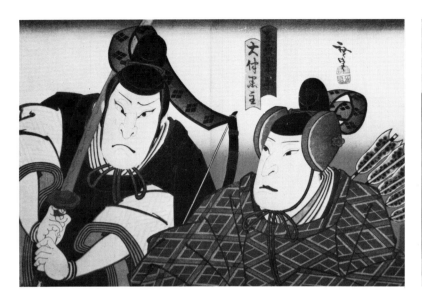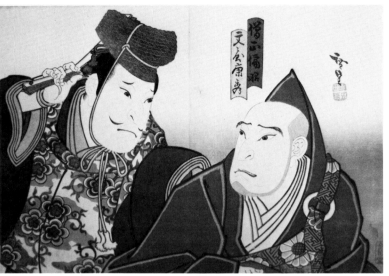

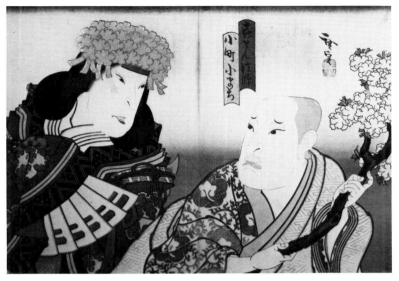

Number 52.
Nakamura Utaemon IV as Kisen Hōshi, Ariwara no
Narihira, Ōtomo no Kuronushi, Sōjō Henjō and
Bun'ya no Yasuhide.
Nakayama Nanshi II as Ono no Komachi
in *Yosooi rokkasen*, "The Six Immortal Poets in Full
 Dress," Naka Theater
Chūban format
Collection: Private collection, New York

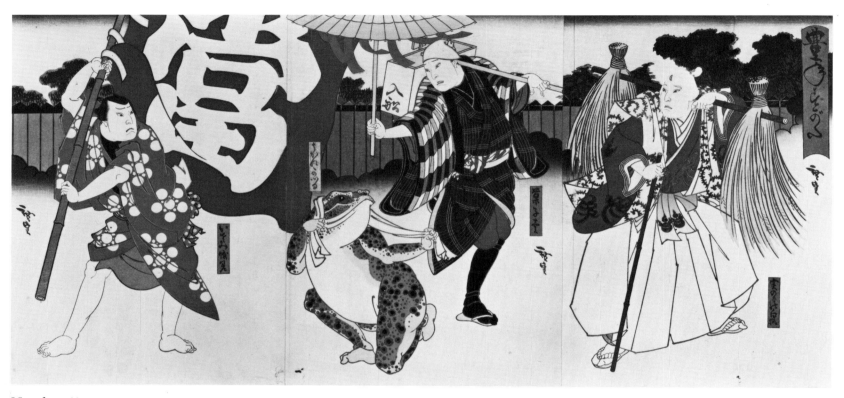

Number 53
Onoe Tamizō II as *minori no shiragitsune*, (the White Fox
 of Plenty), a street vendor, *ukare no kaeru* (a fickle frog),
 and a standard bearer
in *Honen sugata*, "Aspects of a Plentiful Year,"
 Wakadayū Theater
Chūban triptych
Collection: Ikeda Bunko Library, Japan

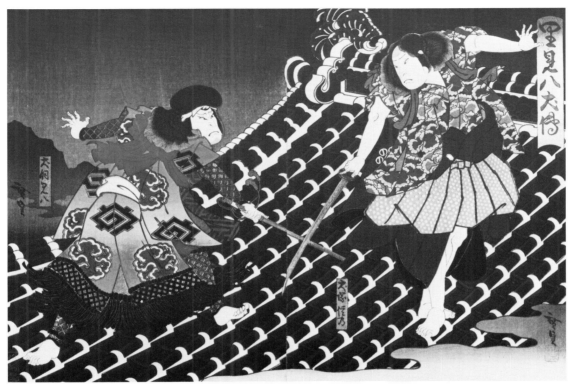

Number 54a
Kataoka Gadō II as Inuzuka Shino
Kataoka Ichizō II as Inugai Kempachi
in *Hana no ami tsubomi no yatsubusa*, "The Eight Buds of
 Plum Blossom," Chikugo Theater
Chūban
Collection: Donald Dame, Long Beach, California

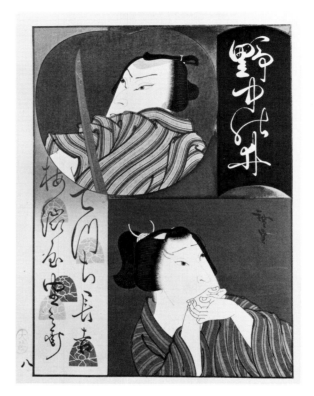

Number 56
Arashi Rikaku II as Ume no Yoshibei
Nakamura Tamashichi as the apprentice Chōkichi
in *Akanezome nonaka no kakureido,* "Red Dye in the
　　　　Hidden Well in the Countryside," Chikugo Theater
Chūban format
Collection: Donald Dame, Long Beach, California

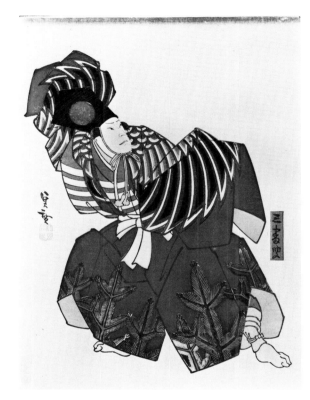

Number 57a
Arashi Rikaku II as Sambasō
in *Hatsuyagura tanemaki sambasō*, "Sambasō Sows Seeds
 from the New Tower," Chikugo Theater
Chūban format
Collection: Ikeda Bunko Library, Japan

CATALOGUE
OF THE EXHIBITION

All works unless otherwise noted are by Hirosada. Works documented for illustrative purposes only are so indicated; an asterisk denotes black and white or color plate. Dimensions are as follows:

Ōban or full-block, @ 15″H x 10″W
Chūban or half-block, @ 10″H x 7½″W

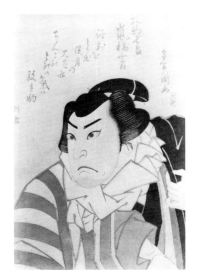

Number 1

1. Arashi Kichisaburō II as Hanaregoma Chōkichi
 in *Futatsu chōchō kuruwa nikki*, "Two Butterflies:
 A Diary of the Licensed Quarters," Naka Theater
 11 / 1823
 Ōban format
 Signature: Tamikuni ga
 Publisher: Tokuraya Shimbei (Toshin)
 Collection: Jan van Doesburg, The Netherlands

The two "butterflies" in this play were amateur *sumō* wrestlers. Rowdy, antagonistic and dissolute at the beginning of the play, Hanaregoma, "Untethered Horse," Chōkichi eventually swears friendship with a rival, Chōgorō, and helps him escape to safety. The first confrontation between the wrestlers is one of the highlights of the play; three prints by

Hirosada of the same scene performed by different actors in 1849 and 1851 are included as catalogue no. 24.

This bold close-up portrait, one of Hirosada's earliest prints, was modelled after other large heads of kabuki actors with yellow backgrounds designed in the early 1820s by Ōsaka artists such as Jukōdō Yoshikuni and Shunkōsai Hokushū. Pictures of this type may have been private publications since early impressions usually bear a short eulogistic verse. The poem on this print was composed by the publisher Tokuraya Shimbei. It ends with the wrestler's name and indicates that the actor who now performed regularly in the leading Ōsaka kabuki theaters had first starred in *chinko no shibai*, the children's theater:

> "He plays the major theaters with great acclaim; spirited as an untethered pony in his youth," *Hyōban o toride yakusha no ōshibai chinko no toki no ki wa hanaregoma.*

76

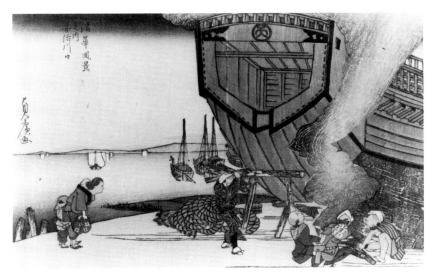

Number 2

2. *Ajikawa guchi*, "The Mouth of the Aji River
 from the series Naniwa fūkei no uchi "Views of Ōsaka"
 ca. 1836
 Ōban format
 Signature: Sadahiro ga
 Publisher: Temmaya Kihei (Tenki)
 Collection: Philadelphia Museum of Art, Pennsylvania
 Purchased by subscription and with a donation
 from the Lola Downin Peck Fund.

Soon after his return to Ōsaka in 1835 from his second sojourn in Edo as a pupil of Utagawa Kunisada, Hirosada began a series of landscape views of his native city and its environs which were issued by one of the leading Ōsaka book and print publishers, Temmaya Kihei, whose circular emblem appears on the stern of the ship in this print. The rising smoke is depicted by white lines carved in reserve on a block printed with color graduation. Hirosada adopted this representational technique from Hokusai's picture of sawyers in the mountains of Tōtomi Province published in the series *Thirty-six Views of*

Mt. Fuji in the early 1830s. The subject of caulking a beached ship may have been inspired by Hokusai's illustration on pages 17b-18a of volume 3 of *100 Views of Mt. Fuji*.

The gently humorous style of the figures in the print, however, is taken from prints by Hiroshige. The woman at the left with the baby on her back recalls a figure in the picture of *Drying Strips of Gourd at Minakuchi*, plate 51 of the first Tōkaidō series published in 1833, while Hirosada was in Edo, by Takenouchi Hoeidō. Other elements in the picture, particularly the choice of colors, and the techniques of engraving and printing, seem to be derived from pictures such as *Matsuida, Shionada*, and *Ōkute* from *Sixty-nine Stations of the Kisokaido*, a set to which Hiroshige contributed twenty designs around the end of 1835 and the beginning of 1836.

Two other landscapes from the "Views of Ōsaka" are presently known: a spring view of outdoor teahouses at the Umeyashiki plum orchard and a depiction of the Temma and Tenjin Bridge over the Ōkawa River (figure 1). These prints are illustrated in Kuroda, plates 121 and 122, and in Matsudaira (1975), plates 189a and 189b.

77

Number 3

3. The geisha Matsuume and Tora II of the establishment
 Chūshinken (or Nakamoriken)
 from the series *Shimanouchi nerimono*, "Costumes in the
 Shimanouchi District"
 7/1837
 Ōban diptych
 Signature: Gochōtei Sadahiro ga
 Seal: Sada
 Publisher: Temmaya Kihei (Tenki, Shinsaibashi
 Yawata-suji, Ōsaka)
 Collection: Philadelphia Museum of Art, Pennsylvania
 Purchased by subscription and with a donation
 from the Lola Downin Peck Fund.

The major kabuki and puppet theaters in Ōsaka were
located between the Ebisu and Nihon Bridges along the south
bank of the Doton Canal. Directly across the canal lay the
Shimanouchi entertainment district, a congeries of restau-
rants and teahouses. The district sponsored annual events in
which waitresses, geisha and other female entertainers donned
elaborate costumes and performed skits or pantomimes. In
1836, the artist Hokuei designed a series of prints of these
women in costume. The following year Hirosada designed
pictures of two geisha employed by an establishment called
Chūskinken (or Nakamoriken). The series title, the name of
the woman and her place of employment are written on a
cartouche in the shape of a wooden plaque, which supports a
fan bearing the name of the woman's role. Matsuume is
dressed as a maid (*hashitame*) carrying a football suspended
from a leafy branch; Tora (the second woman to bear this
name) carries a basket of freshly picked spring herbs.
Sadanobu, Shigeharu and a pupil of Hokuei named Hokuju
also contributed designs to the set.

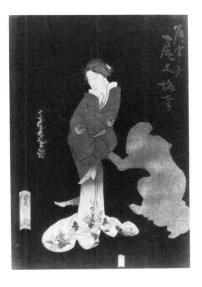

Number 4

4. Onoe Kikugorō III (Baikō) as the spirit of
 the courtesan Usugumo
 in *Ume no hatsuharu gojūsantsugi*, "Plum Blossoms in
 Early Spring and the Fifty-three Stations of the
 Tōkaidō," Kado Theater
 4/1841
 Ōban format
 Signature: Sadahiro ga
 Publisher: Shōhon'ya Seishichi (Honsei)
 Collection: Haber Collection, New York

The Edo actor Onoe Kikugorō III, celebrated for roles
with overtones of the supernatural or macabre, performed
briefly in Ōsaka on four occasions between 1820 and his death
in 1849. In his season debut in 1841 he performed seven roles
including the ghost of a courtesan named Usugumo in a play
based on mysterious events along the Tōkaidō Road between
Edo and Kyōto. According to the theatrical records of the
period, Kikugorō received less acclaim for this performance
than he had on his previous visit fifteen years earlier. In
Hirosada's print, the burning flame indicates that the courte-
san is a spirit. The grey figure of the stagehand who holds the
flame is carved in reserved from the black block of the
background; he seems even more ghostly and insubstantial
than the courtesan. A close-up portrait of Kikugorō in this
role is illustrated in the next entry. For prints designed by
Hirosada of Kikugorō in roles performed during his last visit
to Ōsaka in 1848-49, see catalogue nos. 9, 21 and 22.

Number 5a

5a. Nakamura Shikan III as Ki no Haseo
in *Temmangū natane no osanae*, "The Rape Seed Offering
at the Temman Shrine," Naka Theater
4 / 1841
Chūban format
Signature: Sadahiro ga
Collection: The Fine Arts Museums of San Francisco,
Achenbach Foundation for Graphic Arts,
Mrs. Alexander de Bretteville Fund, 1983

Between the end of 1840 and the middle of 1841, the
ship-builder and amateur print designer Sadamasu designed
approximately ten large heads of actors in the half-block

(*chūban*) format, reviving a style of portraiture that had been
popular in Ōsaka in the 1820s. Hirosada, his protegé, designed
two prints for the group which were more intense and
dramatic than the works by his patron.

"The Rape Seed Offering" is a dramatization of the
conflict between the statesman Sugawara no Michizane (Kan
Shōjō) and his rival Fujiwara no Tokihira (Shihei), a courtier
who plotted to usurp the imperial throne. Nakamura Shikan
performed two roles in the play: one, the samurai Ki no
Haseo, shown here holding a daggar in a brocade pouch, the
other, the wicked courtier Tokihira. Hirosada designed a large
sumptuously printed picture of the latter posing triumphantly
on the steps of the palace at the conclusion of the play.

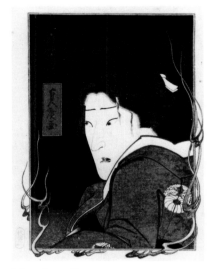

Number 5b

5b. Onoe Kikugorō III is the spirit of the courtesan Usugumo
 in *Ume no hatsuharu gojūsantsugi,* "Plum Blossoms in
 Early Spring and the Fifty-three Stations of the
 Tokaido," Kado Theater
 4/1841
 Chūban format
 Signature: Sadahiro ga
 Collection: Ikeda Bunko Library, Japan

 Hirosada designed a full-length portrait in a large format
of the Edo actor Kikugorō in the role of Usugumo
(catalogue no. 4).

*6. Ichikawa Ebizō V (Danjurō VII) as the warrior
 Akushichibyōe Kagekiyo
 in *Keisei soga kamakura daijin*, "The Courtesan, the Lord
 of Kamakura, and the Soga Clan," Naka Theater
 from the series *Chūkō buyūden*, "Tales of Loyalty,
 Bravery and Filial Devotion"
 1/1848
 Chūban format
 Signature: Hirosada
 Collection: Donald Dame, Long Beach,
 California (print, two versions)
 Philadelphia Museum of Art, Pennsylvania
 (drawing). Purchased by subscription and with a
 donation from the Lola Downin Peck Fund.

After the defeat of his clan in the battle of Yashima, the
Taira warrior Kagekiyo vowed to take revenge on Yoritomo,
the victorious general. When Yoritomo attended a ceremony
at Tōdai-ji, a temple in the city of Nara, Kagekiyo disguised
himself as a priest, but was recognized by Hatakeyama
Shigetada, one of Yoritomo's retainers, and was captured
before he could kill his enemy. Shigetada draws his sword and
challenges Kagekiyo but the warrior, refusing to acknowledge
him; holds his hands in a symbolic religious gesture and
continues to pray with closed eyes. Yoritomo mercifully spared
Kagekiyo's life but for self-protection had him blinded and
sent into exile. The blind Kagekiyo lived for many years as an
outcast on a remote island until he was pardoned and allowed
to return to Kamakura.

Ichikawa Ebizō V (1791-1859), the greatest Edo kabuki
actor of the first half of the nineteenth century, was banished
from his native city in 1843 for violating the government's

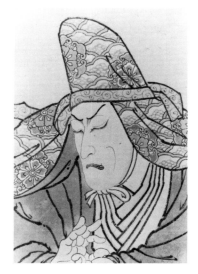

Number 6 (drawing)

sumptuary laws and was not allowed to return until 1850.
Although he eventually settled in Ōsaka, during this period
he travelled and performed throughout Japan. In 1853 he
returned to Ōsaka and performed there until 1858, the year
before his death. Hirosada's original colored brush drawing
for the print is nearly identical in design to the published
version, although it differs extensively in detail and lacks the
artist's signature, the series title, and the printed name of the
actor's role. Two impressions of the published print are
exhibited here: the earlier has extensive overprinting on the
priest's hat and a multi-colored title cartouche whereas the
later impression is printed with fewer colors and less care on
thinner paper.

*7. Arashi Rikaku II as Hanaregoma Chōkichi
Kataoka Gadō II as Nuregami Chōgorō
Kataoka Ichizō I as Onigatake
Ichikawa Ebizō V as Kinugawa Tanizō
Jitsukawa Ensaburō as Shirafuji Genta
from the series *Chūkō sekitori kagami,* "A Mirror of Filial
 and Loyal Wrestlers"
Mid-1848
Chūban pentaptych
Signature: Hirosada
Publisher: Kinkadō, Konishi
Engraver: Hori Uchitora
Collection: Ikeda Bunko Library, Japan

Although most of Hirosada's prints commemorate particular kabuki performances, "The Mirror of Wrestlers" depicts five leading actors of the Ōsaka stage in different plays in an imaginary tableau. In the kabuki repertoire, wrestlers were large, swaggering, combative figures, ready to speak out against injustice and to correct social as well as personal wrongs. In his choice of costume patterns and the placement of each figure Hirosada conveys both the aggressive boldness that the men share in common and the aspects of character which distinguish each role. Without narrative constraints Hirosada was freer than usual to explore the shallow, confined space in which he usually placed his figures during this period. The cartouche around the actors' role names is a stylized form of the *toshidama,* an emblem used by Kunisada and other members of the Utagawa school of print designers. It appears as a cartouche on Hirosada's prints only between the fifth and eighth months of 1848.

*8. Arashi Rikaku II as Kisuke, the cook
Sawamura Kitō as Okon
Kataoka Gadō II as Mitsugi
in *Ise ondo koi no netaba,* "A Song of Ise and
 the Vengeful Blade of Love,"
from the series *Chūkō buyūden,* "Tales of Loyalty,
 Bravery and Filial Devotion"
4/1848
Chūban triptych
Signature: Hirosada
Publisher: Kinkadō, Tenki
Collection: Donald Dame, Long Beach, California

Mass pilgrimages to the Shinto shrine at Ise occurred periodically during the Edo period. During the pilgrimage of 1796, a samurai named Fukuoka Mitsugi stopped at a teahouse in the town of Furuichi near Ise to seek a famous sword that had disappeared from his master's family. Mitsugi's lover, Okon, was a courtesan at the teahouse and knew that another guest at the inn held the crucial certificate of authenticity for the sword. To obtain the certificate, Okon pretended to reject Mitsugi in favor of the guest. Overcome with jealous rage, the samurai ran amok and killed Okon and several other guests in the teahouse before he was captured. In Hirosada's prints Mitsugi has drawn his sword, and Okon, one hand raised to fend off the coming blow, has turned away from him, while Kisuke helplessly observes.

The patterns on the actors' robes in these prints are brilliantly drawn and printed. As in similar portraits designed during this period by Kunisada, Hirosada's teacher, they seem to have a life of their own, independent of the human drama they record. During 1848 Hirosada explored the formal beauty of patterns, but in the following year he began to subordinate them to the overall dramatic effects he sought to create.

*9. Ōkawa Hashizō (Onoe Kikugorō III) as Shirai Gompachi
 in *Sangoku ichi tsui no kuromono*, "A Pair of Blackguards:
 The Best in the World," Kado Theater
 8/1848
 Ōban format
 Signature: Hirosada ga
 Seals: Konishi Gochō
 Collection: The Fine Arts Museums of San Francisco,
 Achenbach Foundation for Graphic Arts,
 California, purchase, 1981

In the autumn of 1847 the Edo actor Onoe Kikugorō III retired briefly from the theater, but after a few months of inactivity he adopted a new stage name, Ōkawa Hashizō. In the summer of 1848 he travelled to Ōsaka where he performed simultaneously with great acclaim at two of the three major theaters, acting in a historical play at the Kado Theater in the morning and a domestic drama at the Naka Theater in the afternoon. In the finale of the historical play Shirai Gompachi, the young Edo outlaw, commits suicide on a boat at night in order to avoid ignominious capture. A fiercely compelling design, the tip of the boat's prow pierces the darkness as sharply as the bloody tip of Gompachi's sword. The verse compares the outlaw's brief but glorious life with cherry blossoms: "Flowers of the mountain cherry: praised as they fall" (*Yamazakura chiru toki koso o homare kana*). The white patterns on the actor's robe are the syllable *Ki* and *Ro*, taken from the name Kikugoro, the circular emblem with the character *i* in a circle was Gompachi's personal crest.

Bloody suicides and murders grew increasingly common on the kabuki stage in the decades preceding the civil struggles which led to dissolution of the Tokugawa shogunate and the restoration of imperial rule in 1868. Hirosada was one of the first artists to explore the gruesome beauty of blood in woodblock prints and this picture antedates by fifteen years the better-known pictures of blood by the Edo artists Yoshitoshi and Yoshiiku.

*10. Arashi Rikaku II as a pony dancer
 Nakamura Tamashichi as a *manzai* dancer
 Sawamura Kitō as a street musician
 in *Aratamaru oshika omoiba*, "To Think of How the
 Mandarin Ducks Have Changed," Chikugo Theater
 1/1849
 Chūban triptych
 Signature: Hirosada
 Seal: Unread
 Publisher: Kinkadō
 Collection: Donald Dame, Long Beach, California

This print and the two following were published to commemorate the stage debut of Nakamura Tamashichi, the twelve year old son of the kabuki actor Nakamura Shikan III. *Tama*, the first character in the boy's name, means "jewel" and the decorative pattern on the boy's robe in this print is composed of jewels. Another visual pun in the pictures may also have been intentional: the first word in the play title contains the syllable *maru*, or "circle," and two circular hand-drums are conspicuous elements in the design. The verse above the child's head says: "Patrons throng to the sleeves of the *manzai* dancer" (*Manzai no sode ni gohiiki sakarikeri*). It is possible that the print was privately commissioned for distribution to the child's patrons and supporters in the theater world. *Aratamaru* means "changed" and the panto-mime of the street dancers was followed by a quick change of costume and scenery as the three actors were transformed into mandarin ducks (see catalogue nos. 11 and 12).

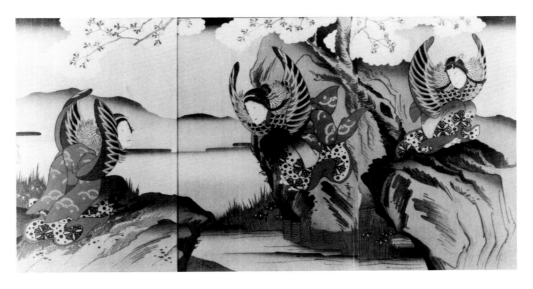

Number 11

11. Nakamura Tamashichi, Sawamura Kitō and
 Arashi Rikaku II as mandarin ducks
 in *Aratamaru oshika omoiba*, "To Think of How the
 Mandarin Ducks Have Changed,"
 Chikugo Theater
 1/1849
 Ōban triptych
 Signature: Hirosada
 Seals: Konishi, Gochō
 Publisher: Konishi Kinkado (?)
 Collection: Haber Collection, New York

In Japan, mandarin ducks are a symbol of married happiness and fidelity. The devotion of these birds to one another is so deep that one member of a pair cannot long survive the death of its mate. Tamashichi's father Nakamura Shikan III died at the end of 1847 and the choice of this play for his stage debut in a major Ōsaka theater suggests that his mother had died soon afterwards, leaving him orphaned. In Hirosada's print the young bird perches on a rock beside its parents in a dreamy timeless landscape where irises have bloomed but the cherry blossoms have yet to fall.

Like earlier Ōsaka artists, Hirosada drew the figures and the landscapes in this triptych in contrasting styles. He increased the contrast by using cool blues and greys for the landscape and warm reds, purples, and yellows for the birds. Late impressions of this subject have fewer color blocks, a yellow sky, one pale blue block for the water, and no mountains on the horizon. In addition, they lack the embossing on the flowers and all overprinting. Hirosada designed very few triptychs in the large *ōban* format, another is illustrated as catalogue no. 31.

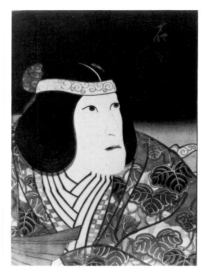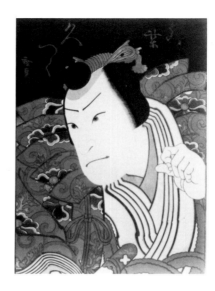

Number 13a.

*12. Sawamura Kitō, Nakamura Tamashichi and
 Arashi Rikaku II as mandarin ducks
 in *Aratamaru oshika omoiba*, "To Think of How the
 Mandarin Ducks Have Changed,"
 Chikugo Theater
 1/1849
 Chūban triptych
 Signature: Hirosada
 Seal: Rankei
 Publisher: Kawaoto
 Collection: Donald Dame, Long Beach, California

The young actor Tamashichi floats in the center panel in the midst of a flaming blue circular jewel as though he had just been transported into the presence of his deceased parents in the spirit world. The poem beneath his portrait is a tender eulogy of his parents: "I've had mandarin ducks teach me how to play in the water" (*Oshidori ni oshiete morau mizu asobi*).

13a. Jitsukawa Ensaburō as the regent Hisatsugu
 Ichikawa Ebizō V as Ishida no Tsubone
 in *Keisei ishikawazome*, "The Courtesan in a Robe of
 Dyed Ishikawa Cloth," Naka Theater
 1/1849
 Chūban diptych
 Signature: Hirosada
 Seal: Unread
 Publisher: Kawaoto
 Collection: Donald Dame, Long Beach, California

After the Lord of Tajima was killed by the Toyotomi clan at the end of the sixteenth century for supporting the disloyal general Mitsuhide, his wife adpoted the name Ishida no Tsubone and vowed to avenge his death. Obtaining entrance to Jurakudai, the palace of the Toyotomi clan, Ishida planned to kill the regent Hidetsugu (or Hisatsugu as he is called in the

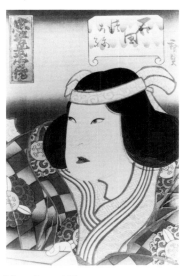

Number 13b.

dramatized version of the story). However, she was recognized while performing in a Nō play and forced to commit suicide before she could achieve her goal.

In this diptych, Hirosada portrays the moment of recognition: Ishida glowers at the regent from the stage and Hisatsugu draws his sword to protect himself. The artist's depiction of Ishida is tense, brooding and severe, particularly in comparison to a portrait of Arashi Rikan in the same role which he designed a year earlier (see catalogue no. 13b). The sudden and striking change in Hirosada's style at the beginning of 1849 is clearly visible in these two prints.

Ishida's wrath was perpetuated after her death by her son Ishikawa Goemon, an outlaw who constantly attacked and embarrassed the government. Ebizō also performed the role of Goemon in this play and Hirosada designed a print in the *ōban* format of the outlaw carrying a large case on his back.

13b. Arashi Rikan III as Ishida no Tsubone
in *Keisei ishikawazome*, "The Courtesan in a Robe of Dyed Ishikawa Cloth," Chikugo Theater
from the series "Tales of Loyalty, Bravery and Filial Devotion," *Chūkō buyūden*
1/1848
Chūban format
Signature: Hirosada
Collection: Donald Dame, Long Beach, California

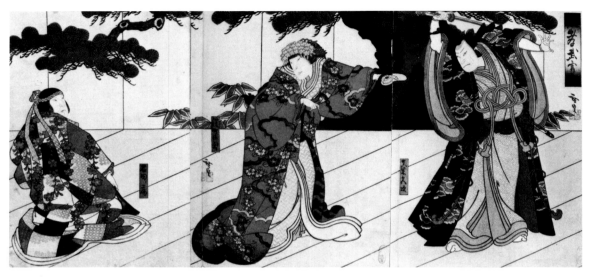

Number 13c.

13c. Jitsukawa Ensaburō as Mashiba Hisayoshi
 Nakayama Nanshi II as Yodomachi Gozen
 Nakamura Utaemon IV as Ishida no Tsubone
 8/1850
 Chūban triptych
 Signature: Hirosada
 Seal: Rankei
 Publisher: Kawaoto
 Collection: Donald Dame, Long Beach, California

*14. Mimasu Daigorō IV as Umako Daijin
 Ichikawa Ebizō V as Umaya Daijin
 Jitsukawa Ensaburō as Prince Shōtoku
 in *Shitennōji garan kagami*, "The Monastic Mirror at the
 Temple of the Four Guardian Kings," Naka Theater
 3/1849
 Chūban triptych
 Signature: Hirosada
 Publisher: Kita Kagawa
 Collection: Donald Dame, Long Beach, California

This play was performed to celebrate the 1233rd
anniversary of the founding of the first Buddhist temple in
Ōsaka, Shitennō-ji (Temple of the Four Guardian Kings), by
Prince Shōtoku in the seventh century. The story of the play
was loosely based on historical events: after the death of the
emperor Yōmei in 587 rivalry broke out between two powerful
courtiers, Soga no Umako and Mononobe no Moriya (Lord

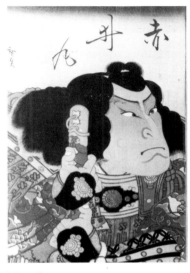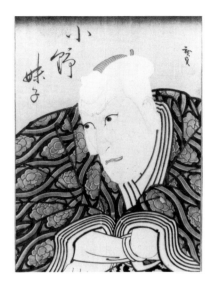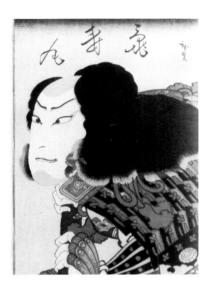

Number 15

Umako and Lord Umaya in the drama), each of whom supported a different prince for the succession. Umako killed Moriya, installed his protégé as the emperor Sushun, but soon replaced him in favor of a niece, the Empress Suiko, appointing her talented nephew, Prince Shōtoku, as a regent.

In the stage play the story is simplified: Lord Umaya is older and more powerful than Umako. A malignant character, Umaya is determined to rule the nation himself by any means. In this scene, rays of light surround his body with an aura of invincible strength as he confronts Umako and Prince Shōtoku, his rivals. To protect themselves from Umaya's baleful influence Umako holds a minature pagoda and Shōtoku an arrow. Frontal portraits are very uncommon in Japanese woodblock prints and Hirosada exaggerated Ebizō's features to make him seem the very personification of evil. For a very different portrayal of the actor in another role in this play see catalogue no. 15.

15. Mimasu Daigorō IV as Kijumaru
 Ichikawa Ebizō V as Ono no Imoko
 Kataoka Ichizō as Akaimaru
 in *Shitennōji garan kagami*, "The Monastic Mirror at the
 Temple of the Four Guardian Kings," Naka Theater
3 / 1849
Chūban triptych
Signature: Hirosada
Seal: Rankei
Publisher: Kawaoto
Collection: Donald Dame, Long Beach, California

Ono no Imoko, the elderly man portrayed in the center panel of this triptych, was a courtier and statesman during the reign of Empress Suiko who travelled to China as an official government emissary in 607 at the request of Prince Shōtoku. Hirosada portrays him at the moment he intervenes in a dispute between his fair son Kijumaru, the warrior at the right, and the rough, red-faced soldier Akaimaru who presumably served Lord Umaya, the villain.

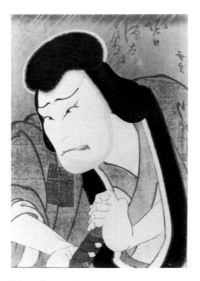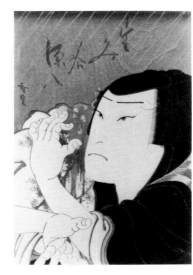

Number 17

*16. Kataoka Gadō II as Tamiya Gempachi
 Nakamura Gizaemon as Horiguchi Gentazaemon
 in *Osanago no adauchi*, "The Child's Revenge,"
 Chikugo Theater
 3/1849
 Chūban diptych
 Signature: Hirosada
 Seal: Ko
 Publisher: Meikōdō
 Collection: Donald Dame, Long Beach, California

Gentazaemon and Gempachi are the fictionalized names of two samurai in the service of the Lord of Sanuki Province at the beginning of the seventeenth century. Gentazaemon was a former fencing instructor, and Gempachi was also accomplished in that art. At the beginning of "The Child's Revenge," the two fight the duel depicted here and Gempachi won. The older man, mortified to lose and frightened by Gempachi's skill, soon found an occasion to murder him (see catalogue no. 17).

17. Nakamura Gizaemon as Horiguchi Gentazaemon
 Kataoka Gadō II as Tamiya Gempachi
 in *Osanago no adauchi*, "The Child's Revenge,"
 Chikugo Theater
 3/1849
 Chūban diptych
 Signature: Hirosada
 Publisher: Ueda
 Collection: Philadelphia Museum of Art, Pennsylvania
 Purchased by subscription and with a donation
 from the Lola Downin Peck Fund.

After losing a fencing match with wooden swords (see catalogue no. 16) Gentazaemon arranged to meet Gempachi unarmed on a rainy night and murdered him. A few months later, a son named Bōtarō was born to Gempachi's widow. The child was raised with the sole thought of avenging his father's death and he accomplished this in 1641 at the age of eighteen (or seventeen by western reckoning).

*18. Arashi Rikaku II as Osome and Hisamatsu
 in *Osome hisamatsu ukina no yomiuri*, "Osome,
 Hisamatsu and the News of their Love,"
 Takeda Theater
 3/1849
 Chūban diptych
 Signature: Hirosada
 Seal: Rankei
 Publisher: Kawaoto
 Collection: Donald Dame, Long Beach, California

In the main plot of "The News of their Love,"
Hisamatsu, a nobleman, becomes an apprentice at a pawn-
shop, the Aburaya, in Edo in order to search for a precious
heirloom sword that had been stolen from his family. Soon he
falls in love with Osome, the proprietor's daughter. Osome
returns his love, but he is already betrothed. Unable either to
consummate their love or to renounce one another, the
couple plan to commit suicide on the bank of the Sumida
River; they are saved and the family sword is recovered and
returned.

The play was first performed in Edo in 1813 and became
a popular vehicle for virtuoso acting since the seven important
roles: Osome, her mother Teishō, Hisamatsu, his sister
Takegawa (a lady-in-waiting), his fiancé Omitsu, the evil maid
Oroku, and Osaku, were all performed by one actor with
quick changes. In this pair of prints the two lovers could not
appear at the same time. Rikaku probably hid behind the
umbrella to make his costume change.

*19. Arashi Rikaku II as "Cast-off" Oroku
 Asao Yoroku I as Kimon no Kihei
 in *Osome hisamatsu ukina no yomiuri*, "Osome,
 Hisamatsu and the News of their Love,"
 Takeda Theater
 4/1849
 Chūban diptych
 Signature: Hirosada
 Seal: Ko
 Publisher: Meikōdō
 Collection: Donald Dame, Long Beach, California

In the sub-plot of "The News of their Love" Kimon no
Kihei steals Hisamatsu's family's sword and pawns it at the
Aburaya where his mistress, Oroku, works as a servant. Two
clerks employed at the pawnshop quarrel; one is killed, and
Kihei carries his corpse to the shop, hoping to extort some
money from the proprietor. As Kihei, directing the palanquin
bearers, approaches in the distance, Oroku leans against a
post in the house and awaits his arrival. Japanese print
designers rarely changed scale by combining full-length and
half-length figures in different panels of a single composition.
The picture of the thief and the palanquin, rather unattrac-
tive by itself, succeeds in directing the viewer's gaze to the
unperturbed figure of Oroku at the right and together the
two sheets convey a sense of physical, temporal and even
moral separation.

*20. Arashi Rikaku II as Hisamatsu
in *Osome hisamatsu ukina no yomiuri*, "Osome,
　　Hisamatsu and the News of their Love,"
　　Takeda Theater
4 / 1849 / *Chūban* format
Signature: Hirosada
Publisher: Kita Kagawa
Collection: Donald Dame, Long Beach, California

This print is a panel of a diptych and without the companion picture the action of the scene is unclear. The bright lining on Hisamatsu's robe is part of a woman's costume, not a man's, so this may represent the first night tryst between the lovers in the warehouse of the pawnshop, or their last appearance together on the bank of the Sumida River as they attempt double suicide at the end of the play. The print is unusual both for the emotional intensity of its color and for the direct engagement of the viewer by the actor's gaze.

*21a. Onoe Kikugorō III as the ascetic priest Nakasaina
Ichikawa Ebizō V as Nippon Daemon
in *Gotaiheiki shiraishi banashi*, "The Story of Shiraishi
　　and the Chronicles of Peace," Kado Theater
8 / 1848
Plate 1 from an untitled series published in 5 / 1849
Chūban format
Signature: Hirosada
Publisher: Ueda
Private collection

The elderly actor Onoe Kikugorō III (1784–1849) returned to the stage in Ōsaka in the eighth month of 1848. Although he fell ill during his first performance, he continued to appear. After the spring season in 1849, he left Ōsaka, but he grew more ill and died in the town of Kakegawa on the Tōkaidō Road on the 24th day of the fourth month. Soon afterwards, Hirosada designed a commemorative set of five numbered horizontal prints of the actor in his best recent roles. This is the first print in the series: a battle of supernatural abilities between the evil Indian ascetic Nakasaina and Nippon Daemon, a Japanese magician who has changed the rock in the foreground into a toad. Nippon Daemon was played by Ichikawa Ebizō V, another celebrated Edo actor. Ebizō, a poet and calligrapher, contributed the memorial verse printed in gold against the black background (it is signed with his poetry name Sanshō VII): "Cloudy peaks like the ascetic priest of yore," *Sono toki no rakan ni mitari kumo no mine.*

The phrase 'cloudy peaks' both indicates Kikugorō's great accomplishment and fame and recalls the smoke that billowed from his incense burner during this scene. See catalogue no. 21b for another version of the same scene designed by Hirosada as a diptych at the time of the performance.

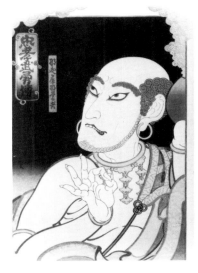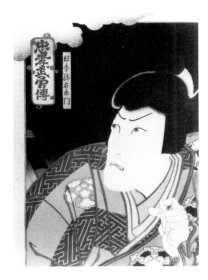

Number 21b.

21b. Onoe Kikugorō III as the ascetic priest Nakasaina
 Ichikawa Ebizō V as Nippon Daemon
 in *Gotaikeiki shiraishi banashi*, "The Story of Shiraishi
 and the Chronicles of Peace," Kado Theater
 8/1848
 Chūban diptych
 Collection: Donald Dame, Long Beach, California

*22. Arashi Rikan as the second Onoe
Onoe Kikugorō III as the ghost of Iwafuji
in *Onoe iwafuji gonichi banashi*, "Recollections of Onoe
 and Iwafuji," Kado Theater
1/1849
Plate 5 from an untitled series published in 5/1849
Chūban format
Signature: Hirosada
Seal: Han
Collection: Ikeda Bunko Library, Japan

A great scandal shook the powerful Kaga clan in 1724. In the dramatization of the story, Nikki Danjō and his wicked sister Iwafuji plot to usurp the shogunate. Onoe, a lady-in-waiting, inadvertently discovers the conspiracy and is forced to commit suicide. Onoe's maid, Ohatsu, kills Iwafuji to avenge her mistress's death and the conspiracy fails. At the end of the play she is promoted in rank and given her former mistress's name as a reward. In Hirosada's picture Onoe poses fearlessly while the ghost of Iwafuji, her dead enemy, shrinks from the butterflies flying toward her. This was the last and most deeply emotional print in Hirosada's commemorative memorial series — Iwafuji was the last role Kikugorō performed before his death.

*23. Ichikawa Ebizō V as Nippon Daemon
Kataoka Gadō II as Tamashima Kōhei
in *Akiba gongen kaisen hanashi*, "The Cargo Vessel and
 the Diety of Akiba Shrine," Chikugo Theater
Intercalary 4/1849
Chūban diptych
Signature: Hirosada
Publisher: Ueda
Collection: Donald Dame, Long Beach, California

In "The Cargo Vessel," Nippon Daemon, leader of a band of outlaws in Tōtomi Province which preys upon travellers, steals a precious poetry manuscript from the head of the Tsukimoto clan. Tsukimoto's loyal retainer Tamashima Kōhei finds Daemon and attacks him, but the unarmed bandit parries his blow and Kōhei is unable either to kill him or retrieve the manuscript. Eventually, through the miraculous intervention of the deity of Akiba Shrine, Kōhei succeeds in killing Daemon and restores his clan's fortunes.

Hirosada designed two sets of prints for the first encounter between Kōhei and Daemon. In the pair of large heads, Kōhei raises his sword while the outlaw hugs one hand to his shoulder to protect the hidden manuscript and holds the other in readiness. In the second pair Daemon laughs at Kōhei whose sword has missed the outlaw and is stuck in a wooden post. Most of the prints Hirosada designed between 1847 and 1849 were close-up portraits of actors. This was one of the first that showed the stage setting for a scene and the actors' physical relationship to one another. He designed many more portraits of this type between late 1849 and 1852.

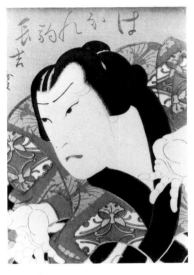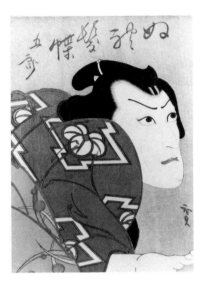

Number 24a

24a. Kataoka Gadō as Hanaregoma Chōkichi
Ichikawa Ebizō as Nuregami Chōgorō
in *Futatsu chōchō kuruwa nikki*, "Two Butterflies:
A Diary of the Licensed Quarters,"
Chikugo Theater
Intercalary 4/1849
Chūban diptych
Signature: Hirosada
Publisher: Kinkadō
Collection: Philadelphia Museum of Art, Pennsylvania
Purchased by subscription and with a donation
from the Lola Downin Peck Fund.

The wrestlers Chōkichi and Chōgorō were originally rivals and this pair of prints shows their first dramatic confrontation in the first act of the play. The setting is an outdoor teahouse by the entrance to a wrestling arena. The two eventually resolve their differences and make common cause for the remainder of the drama.

Hirosada designed two triptychs of this scene in 3/1851: one with the figures shown in full (catalogue no. 24b), another with close-up portraits of the actors (catalogue no. 24c). For an earlier Hirosada portrait of an actor in the role, see catalogue no. 1, for a later scene from the play see catalogue no. 45.

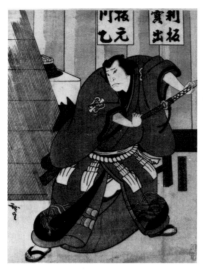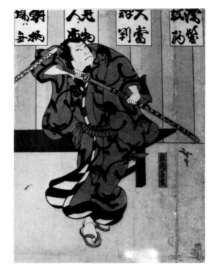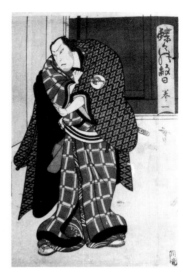

Number 24b.

24b. Mimasu Daigorō IV as Maboroshi Chikuemon
Jitsukawa Ensaburō as Hanaregoma Chōkichi
Nakamura Utaemon IV as Nuregami Chōgorō
in *Hanazumō chōchō no mombi*, "Amateur Wrestling:
 A Special Day for the Butterflies," Naka Theater
3/1851
Chūban triptych
Signature: Hirosada
Publisher: Kawaoto
Collection: Ikeda Bunko Library, Japan
(Illustration only, not exhibited)

This print depicts the confrontation between Chōkichi
and Chōgorō at the entrance to the wrestling arena. For a
later scene from the play, see catalogue no. 45.

*25. Nakamura Daikichi III as Toki Hime
Ichikawa Sukejūrō as Sasaki Takatsuna
Arashi Rikaku II as Miuranosuke
in *Kamakura sandaiki,* "A Chronicle of Three
 Generations in Kamakura"
Mid-1849
Chūban triptych
Signature: Hirosada
Seals: Konishi, Gochō
Publisher: Kinkadō (on early example)
 Tenki (on late example)
Collection: Donald Dame, Long Beach, California

"The Kamakura Chronicle," written for the puppet theater in 1781 and first performed on the kabuki stage in 1818, is loosely based on events surrounding the fall of Ōsaka Castle in 1615 and the final defeat of the Toyotomi clan by Tokugawa Ieyasu. One of the sub-plots of the ten-act drama traced the relationship between Miuranosuke, a warrior, and Toki Hime, the daughter of the general Tokimasa. At the beginning of the play the two men are allies, and the couple is betrothed. As events unfold, however, the men become enemies and the lovers are separated. In Act 7, the mortally wounded Miuranosuke returns to his home and finds that Toki Hime has voluntarily left her family to care for his sickly mother. Toki Hime realizes that since their families are now enemies they can never marry and prepares to kill herself. Miuranosuke, however, promises to marry her if she will kill her father; she agrees to do this. A spy who witnesses this exchange rushes away to inform Toki Hime's father, but a warrior suddenly rises from the nearby well and kills him. This is Sasaki Takatsuna, an ally of Miuranosuke. Takatsuna praises the couple for their devotion and fortitude and the scene ends. Takatsuna's sudden appearance interrupts the conversation between Toki Hime and the wounded Miuranosuke. Miuranosuke eventaully dies in battle, Toki Hime is unsuccessful in her attempt on her father and commits suicide and Takatsuna retires from the world and takes religious orders. The play was performed with a slightly different cast at the Minami Theater in Kyōto in 8/1849. No performance of the play is recorded in Ōsaka, although the theatrical records may be incomplete. It is also possible that the play was scheduled but not performed. In that case the prints might well have been designed and published in advance of the performance. Alternatively, the artist may have chosen the scene for its dramatic and pictorial possibilities, quite independent of an actual performance. Two impressions of the triptych are exhibited in order to show the difference between ordinary and deluxe impressions with gold, silver and other luxurious printing effects.

*26. Onoe Tamizō II as Yomota the apprentice
 Jitsukawa Ensaburō as Hambei the greengrocer
 Onoe Tamizō II as Hambei's mother Okuma
 in *Sewa ryōri yaoya no kondate,* "The Greengrocer's
 Menu of Domestic Fare," Kado Theater
 9/1849
 Chūban tetraptych
 Signature: Hirosada
 Seals: Ko (right panel), Rankei (left panels)
 Publisher: Meikōdō (right panel) Kawaoto (left panels)
 Collection: Donald Dame, Long Beach, California

The shocking suicide of the grocer Hambei and his wife Ochiyo on the precincts of a shrine in Ōsaka in 1722 immediately became the subject of two puppet plays that were soon adapted for the kabuki theater. While Hambei is absent at a memorial service for his father, his adopted mother sends his wife away, annuling their marriage. Hambei meets his wife on his homeward journey and returns home with her but his mother is implacable. Realizing that no reconciliation is possible, Hambei fulfills his obligation to his adopted mother by formally divorcing his wife, but after this is done the two withdraw together and commit suicide.

In this picture, Ochiyo and Hambei try to conciliate Okuma. However, she is unaffected even by the sight of her grandson and reveals her murderous hatred of Ochiyo by showing a dagger concealed at her breast. Hambei apparently fails to see the dagger, but it is seen by the young apprentice Yomota who is standing at a distance holding a lantern inscribed with the name of the greengrocer's shop. The roles of Okuma and Yomota were both performed by the versatile actor Onoe Tamizō in one of his rare appearances at a major theater during this period. The green and purple background adds an air of unnatural and disagreeable emotion to the scene, as though Okuma's mood had literally colored the environment. Hirosada did not use this color scheme on any other prints. The numbering of the prints suggests that Hambei and his mother met alone and that the other actors were present on stage at a distance.

*27. Nakamura Tomozō IV as Igo, the apprentice
 Nakamura Daikichi III as Osono
 in *Kanadehon chūshingura,* "A Writing Manual for the
 Treasury of Loyal Retainers," Chikugo Theater
 9/1849
 Chūban diptych
 Signature: Hirosada
 Seal: Konishi Gochō
 Publisher: Kinkadō
 Collection: Donald Dame, Long Beach, California

The story of the revenge in 1704 of the forty-seven dispossessed samurai of the Lord of Akō for their master's death was a perennial favorite of Japanese theater-goers during the nineteenth century. In order for the vendetta to succeed the samurai needed a warehouse in Edo where they could secretly assemble their weapons and armor. In the dramatization of the story, the building was provided by a merchant named Amakawaya Gihei. At the outset of his involvement with the conspirators Ghiei divorces his wife Osono lest his feelings for her compromise the plan. Osono returns to her father's home, bewildered by her husband's sudden rejection. One night, overcome by misery and loneliness, she makes her way to Gihei's shop hoping to catch a glimpse or word of her infant son. In Hirosada's diptych she conceals her lantern and whispers questions to Gihei's half-witted servant Igo through the shop's barred door.

The set of thirty-two large heads of actors that Hirosada designed for the eleven acts of "The Treasury of Loyal Retainers" performed at the Chikugo Theater in 9/1849 was his most ambitious single project. Twenty-four of the prints were published and drawings for eight others are known. Most of the subjects are illustrated in Keyes and Mizushima, pp. 174–179. Originally Hirosada designed a triptych of Igo meeting two samurai. His decision to replace the men with Osono inspired one of the most beautiful and moving portraits in the series.

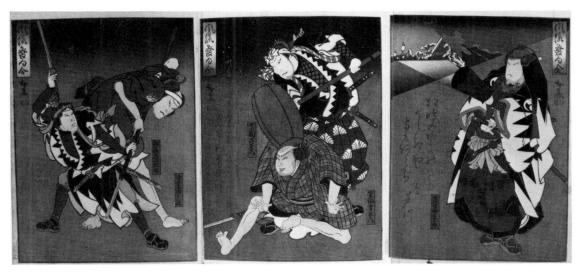

Number 28b

*28a. Kataoka Gadō II as Ōboshi Yuranosuke
Nakamura Tamashichi as Katō Yomoshichi
Mimasu Daigorō IV as Teraoka Heiemon
in *Kanadehon chūshingura*, "A Writing Manual for the
 Treasury of Loyal Retainers," Chikugo Theater
9/1849
Chūban triptych
Signature: Hirosada
Collection: Donald Dame, Long Beach, California

In the final act of *Chūshingura* the forty-seven samurai scale the walls of the Edo mansion of their enemy Kō no Moronao in the early hours of the morning. They catch his household by surprise and succeed in killing him. For mutual recognition during the attack, the samurai wore costumes with a bold jagged sawtooth pattern of black and white as shown in this and the following print. Drawings for the right and center panels of the composition are illustrated in Keyes and Mizushima, p. 178, along with two other drawings which were used for prints published in a decorative but less dramatic five panel compositon published in 3/1848.

28b. Kataoka Gadō II as Ōboshi Yuranosuke
Mimasu Daigorō IV as Teraoka Heiemon
Nakamura Tamashichi as Katō Yomoshichi
in *Kanadehon chūshingura*, "A Writing Manual for the
 Treasury of Loyal Retainers," Chikugo Theater
from the series *Fūryū hokku awase*, "A Collection of
 Elegant Verse"
9/1849
Chūban triptych
Signature: Hirosada
Seals: Konishi, Gochō
Publisher: Kinkadō (?)
Collection: Ikeda Bunko Library, Japan
(Illustration only, not exhibited)

The previous triptych showed three of the forty-seven samurai poised outside Moronao's mansion ready to attack. This triptych depicts the same warriors during the ensuing battle. Yuranosuke raises a lantern to oversee the attach while Heiemon and Yomoshichi easily dispatch two startled and unprepared retainers of Moronao.

*29. Ichikawa Ebizō V as the boatman Yasaburō
 Jitsukawa Ensaburō as Nichiren Shōnin
 in *Nichiren shōnin minori no umi,* "St. Nichiren and the
 Sea of Law," Takeda Theater
 from the series *Nichiren shōnin ichidaiki,* "The Life of
 St. Nichiren"
 10/1849
 Chūban diptych
 Seal: Ko
 Publisher: Meikōdō
 Collection: Ikeda Bunko Library, Japan

This print is one of five diptychs Hirosada designed to
illustrate episodes in this play about the life of St. Nichiren
(1222–1282), founder of a popular and militant sect of
Buddhism. After the mystical and practical power of the Lotus
Sutra had been revealed to him Nichiren attacked other
Buddhist sects for their inefficacy, superstition, laxness and
corruption. The government supported these established sects
and twice sent Nichiren into exile: to Izu in 1260 and to the
island of Sado in 1271. Enroute to Sado, a violent storm arose
but Nichiren calmed the waves by chanting the mantra *Namu
myōhō rengekyō,* "Hail to the Sublime Lotus Sutra," and his
party reached safety. In 8/1849 Hirosada designed a set of
close-up portraits of actors in each act of "The Treasury of
Loyal Retainers." The Nichiren prints designed in 10/1849
were his first attempt to illustrate each major scene in a play
with pictures of full-length figures in descriptive settings. He
must have considered the experiment successful because, from
the spring of 1850 on, his pictures of full-length figures
outnumbered his close-up portraits.

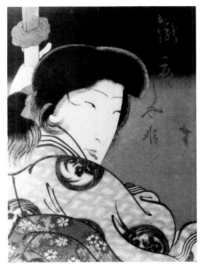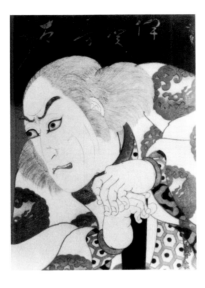

Number 30

30. Ichikawa Ebizō V as Iga no Jūtarō
 Nakamura Daikichi III as Takiyasha Hime
 Late 1849
 Chūban diptych
 Signature: Hirosada
 Private collection

Taira no Masakado, an ambitious and disaffected courtier, left Kyōto at the beginning of the tenth century and established a large domain in the eastern region around the present city of Tokyo. As his power increased, the government grew apprehensive and when imperial troops were sent against him in 940 he was defeated and killed. Two children succeeded him: a son, Soma Tarō, and a daughter, Takiyasha, who both vowed to restore their family's lost fortunes. To obtain supernatural powers like her father's, young Takiyasha took religious orders, became a devotee of the Bodhisattva Jizō and undertook severe silent ascetic practices one winter on Mt. Tsukuba. Her persistence was rewarded and she met an elderly magician named Iga no Jūtarō on the mountain from whom she learned the elements of toad magic. She subsequently returned to her father's ruined palace and worked to restore its former glory. Hirosada's picture shows Takiyasha clad in a white robe at the end of her period of isolation on Mt. Tsukuba. Her hair, which had been cropped when she was a nun, has partially grown out and holds a spear in her hand. The magician Jūtarō faces her.

This performance is not recorded among the published theater documents of the period, however the placement of the role names without cartouches above the actor's heads indicates a date of 1849 and the actors are known to have performed together at the end of that year.

The Edo artist Kunisada may have seen Hirosada's print. In 10/1862 he designed a close-up portrait of the actor Onoe Kikujirō as Takiyasha Hime in nearly the identical pose. An impression of this print is illustrated in *Genshoku ukiyoe daihyakka jiten*, vol. 4, plate 264.

*31. Kataoka Gadō II as Takama Tarō
Nakamura Utaemon IV as Hachirō Tametomo
Arashi Rikaku II as Takama's wife, Isohagi
in *Buyū yumiharizuki,* "Valor and the Crescent Moon"
Late 1849
Ōban triptych
Signature: Hirosada
Seal: Gochō
Publisher: Naniwa Kinkadō Konishi
Private collection

Minamoto no Tametomo (1139–1177), son of the general Tameyoshi by the courtesan Eguchi, was a celebrated archer who fought in the Hōgen Uprising in 1156 and was then exiled to the island of Ōshima. His life was the subject of many fanciful and romantic tales during the Edo period, notably *Chinsetsu yumiharizuki,* "The Crescent Moon," a long and popular novel by Takizawa Bakin illustrated by Katsushika Hokusai which was published in Edo between 1807 and 1811. In the twenty-sixth chapter of volume five of part two of "The Crescent Moon" Tametomo is attacked by a gigantic boar on the slopes of Mt. Udo in Higo Province. As he dispatches the creature with several kicks a local hunter appears and invites him to spend the night at his humble dwelling. After much talk the hunter reveals that he and his wife are sheltering the wife Tametomo had given up for dead and the two are happily rejoined.

Hirosada's triptych, one of his masterpieces, is based upon an earlier work of Hokusai. In adapting the scene to his own format, Hirosada enlarged the figure of Takama Tarō and introduced Takama's wife at the left, although in the novel she was waiting at home. The white patches of falling snow that look like blank holes in the design were probably inspired by a similar effect in a print by Kuniyoshi from the *Suikoden* series published in Edo in the late 1820s during Hirosada's first sojurn there as a student. The picture does not commemorate an actual performance. It was probably published as an homage to the actor Nakamura Utaemon IV who had returned to Ōsaka in the winter of 1849 after twelve years of absence. The ease with which he dispatches the boar suggests that, like Tametomo, he had returned from this period of "exile" with his strength and ability unimpaired. Gadō and Rikaku, two younger actors who never actually appeared with Utaemon on stage during this period, seem to gaze at him with awe and admiration, much as Bakin's hunter and his wife had regarded their unexpected visitor.

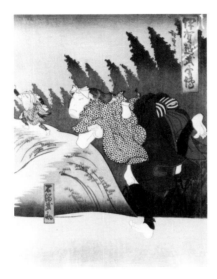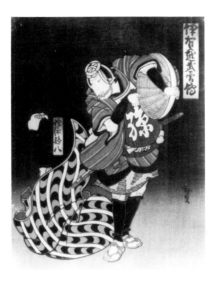

Number 32

32. Jitsukawa Ensaburō as Ikezoe Magohachi
 Nakamura Utaemon IV as Ishidome Busuke
 in *Keisei homare no sukedachi*, "The Courtesan and the
 Proud Second in Battle," Naka Theater
 1/1850
 Two *chūban*
 Signature: Hirosada
 Seal: Mitani (?)
 Collection: Donald Dame, Long Beach, California

In 1632, a samurai was murdered and a sword by the famous smith Masamune was stolen from him. His son, assisted by his sister's husband, identified the murderer and pursued him on his flight throughout Japan. They finally confronted him at Iga Pass in Kōzuke Province at the end of 1634 and obtained revenge by killing him. The story was first dramatized in 1777 and soon ranked with the tale of the forty-seven samurai and the story of the Soga Brothers as one of the three great revenge stories of the kabuki repertoire. Hirosada designed at least ten diptychs, a triptych and three single-sheet prints to illustrate different scenes from this performance.

In the play, Ikezoe Magohachi, samurai in the service of the wronged family, accompanies the avengers on their search. In Hirosada's print, he is dressed in travelling clothes and calmly sidesteps the lunge of an assailant. Ishidome Busuke was an unfriendly samurai who had managed to make his body invulnerable so that no one could either hurt or kill him. In the original play he encounters two men bearing a secret letter which is crucial to the avengers' success. Impervious to their swords, he steals the letter and swallows it.

In Hirosada's version of the scene he chases one of the hapless men. The rising path and the clump of bamboo silhouetted against the sky are adapted from a celebrated view of Shōnō, a station on the Tōkaidō Road, designed by Utagawa Hiroshige while Hirosada was in Edo in the early 1830s.

*33. Nakamura Daikichi III as Ben no Naishi
 Kataoka Gadō II as Kusunoki Masatsura
 Arashi Rikaku II as the fox Matagorō
 in *Kore wa kore wa hana no yoshinoyama*, "Here They
 Are: Flowers in the Yoshino Mountains,"
 Chikugo Theater
 3/1850
 Chūban triptych
 Signature: Hirosada
 Collection: Donald Dame, Long Beach, California

During the fourteenth century one line of the imperial family reigned in Kyōto while another maintained a rival court in the mountains of Yoshino on the Wakayama Peninsula. The chief supporters of this Southern Court, as it was known, were the generals of the Kusunoki family. One winter day while Kusunoki Masatsura was living in Yoshino an unfamiliar woman appeared at his palace and announced that the emperor had sent her to be his wife. Masatsura refused to believe her and she disappeared. Soon afterwards a woman he recognized appeared, saying that she had been sent by a member of the palace work crew named Matagorō. Unexpectedly, at that moment Matagorō himself appeared. Suspecting that supernatural forces were at work in this strange chain of events, Masatsura tossed a wine cup to Matagorō. As Matagorō moved to catch the cup, Masatsura noticed that he left paw prints in the snow. No sooner had he seen this, than both Matagorō and the woman changed into foxes who danced about Masatsura and begged him to return their magic jewel. After overcoming his surprise, the nobleman took pity on the creatures and granted their wish.

Hirosada designed two other pictures for this play. In one Matagorō dances beside the wine cup, in the other he springs through the air towards Masatsura who bends backward in surprise.

*34. Kataoka Ichizō II as the clerk Dempachi
 Nakayama Nanshi as the furniture seller's
 daughter Onaka
 Jitsukawa Ensaburō as the clerk Seishichi
 in *Natsumatsuri naniwa kagami*, "A Mirror of the
 Summer Festival in Ōsaka," Naka Theater
 5/1850
 Chūban triptych
 Signature: Hirosada
 Collection: Ikeda Bunko Library, Japan

"The Summer Festival" is a nine act domestic drama based on the fortunes of the Tamashima clan in Izumi Province. Isonojō, the young family heir, falls in love with a courtesan, spends prodigally and is disinherited by his father, Heidayū. Normally a kind and influential man, Heidayū has secured the release from prison of a quick-tempered, pugnacious fishmonger named Danshichi Kurōbei after which Danshichi secretly repays his obligation to Heidayū by arranging a position for young Isonojō as a clerk in a furniture shop. Isonojō changes his name to Seishichi and soon falls in love with Onaka, the shop owner's daughter.

An enemy of the Tamashima clan prevails on Dempachi, another clerk in the shop, to entrap Seishichi and disgrace him, but Danshichi intervenes and the lovers elope. In this triptych, although *hanamichi* are uncommon in prints of the nineteenth century, Hirosada shows the couple standing on the raised runway. The stage curtain has been closed, focusing the audience's attention on the lovers as they pass Dempachi and make their escape. The bold pattern of bamboo grass on the curtain is the emblem of the Sasase Group, a patronage organization which helped subsidize actors and the chief kabuki theaters in Ōsaka.

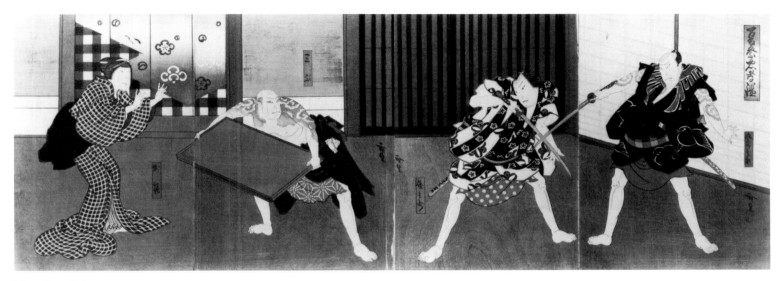

Number 35

35. Nakamura Utaemon IV as Danshichi Kurōbei
Mimasu Daigorō IV as Tokubei
Jitsukawa Ensaburō as Tsuribune no Sabu
in *Natsumatsuri naniwa kagami*, "A Mirror of the
Summer Festival in Ōsaka," Naka Theater
5/1850
Chūban triptych
Signature: Hirosada
Seal: Konishi Gochō
Publisher: Kinkadō
Collection: Ikeda Bunko Library, Japan

The fishmonger Danshichi Kurōbei was imprisoned for quarreling with a samurai. He was granted parole through the intervention of Tamashima Heidayū, a family friend, and released on the understanding that for any misdeed, however slight, he would return to prison. After his release, Danshichi goes to the home of his friend Tsuribune no Sabu to wash and make himself presentable before greeting his wife. At Sabu's house Danshichi is attacked by Issun Tokubei, a swordsman employed by an enemy of the Tamashima clan. Sabu had sworn a vow of non-violence, but fearful that Danshichi would be returned to prison if the fight continued, he seizes a folding screen and separates the two men. In the midst of this commotion Danshichi's wife appears and chides her husband for starting a fight before he had even reached home and seen his family. In the discussion that follows Tokubei and Danshichi become friends and swear to work together to help the Tamashima family.

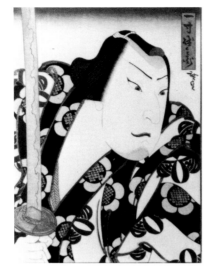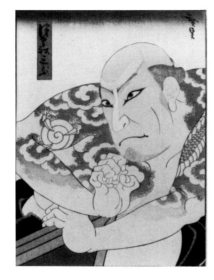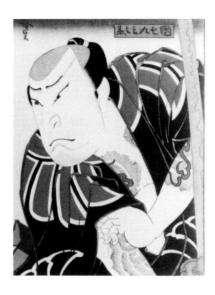

Number 36

36. Nakamura Utaemon IV as Danshichi Kurōbei
 Jitsukawa Ensaburō as Tsuribune no Sabu
 Mimasu Daigorō IV as Issun Tokubei
 in *Natsumatsuri naniwa kagami*, "A Mirror of the
 Summer Festival in Naniwa," Naka Theater
 5/1850
 Chūban triptych
 Signature: Hirosada
 Collection: Donald Dame, Long Beach, California

A close-up version of the scene portrayed in the
previous print. Sabu sits on the floor leaning his arms on the
folded screen to separate the duelling men who stand on
either side glaring at one another and holding their swords in
readiness.

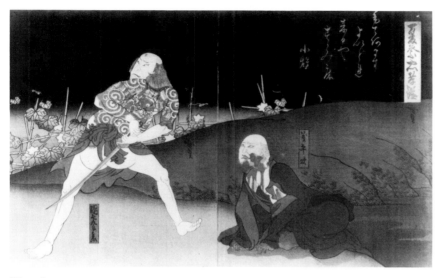

Number 37a.

37a. Nakamura Tomozō as Giheiji
Nakamura Utaemon IV as Danshichi Kurōbei
in *Natsumatsuri chūkō kagami*, "A Mirror of Loyalty
and Filial Devotion During the Summer Festival,"
Naka Theater
5/1850
Chūban diptych
Signature: Hirosada
Publisher: Suri Kame
Collection: Donald Dame, Long Beach, California

The man who tried to incriminate Isonojō (see catalogue no. 34) proves to have been Danishichi's father-in-law, Giheiji, a corrupt old man who abducts Isonojō's former lover to collect a reward offered by an unscrupulous enemy of the Tamashima clan. Danshichi finds Giheiji and offers to pay for the courtesan's release himself. The old man accepts his money but taunts Danshichi knowing that the fishseller will be imprisoned if he quarrels with him. Finally goaded beyond endurance, Danshichi draws his sword and slashes Giheiji, at the same time begging forgiveness for his crime. As Danshichi returns to his senses he hears a fesitval procession approach and hastily conceals Giheiji's body at a nearby well. Hirosada designed three diptychs for this scene. The first is a close-up view of Giheiji shrinking back in fright as he realizes that Danshichi has lost control and means to murder him. In the second, the dying Giheiji creeps out of the mud and snarls at Danshichi (this design). In the third, Danshichi cleanses himself at the well (catalog no. 37b).

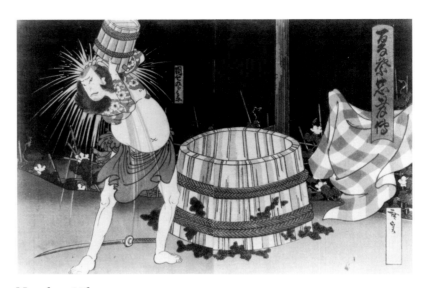

Number 37b

37b. Nakamura Utaemon IV as Danshichi Kurōbei
in *Natsumatsuri naniwa kagami*, "A Mirror of the
Summer Festival in Ōsaka," Naka Theater

5/1850

Chūban diptych

Signature: Hirosada

Publisher: Meikōdō

Collection: Philadelphia Museum of Art, Pennsylvania
Purchased by subscription and with a donation
from the Lola Downin Peck Fund.

*38. Kataoka Ichizō I as Adachi Gen'emon
 Onoe Tamizō II as Homma Saburoemon
 Kataoka Gadō II as Hayase Iori
 in *Tenka chaya*, "The Tenka Teahouse,"
 Chikugo Theater
 8/1850
 Chūban diptych
 Signature: Hirosada
 Seal: Mitani
 Collection: Donald Dame, Long Beach, California

In most Japanese revenge plays the avengers achieve
their goals unscathed. Naturally, they suffer setbacks and
vicissitudes and although they are responsible for their deeds
and often have to commit suicide, at the end of most plays the
villain is dead, the avengers are alive and the audience is left
with the feeling that a wrong has been corrected. "The Tenka
Teahouse," a play based on events that occurred between 1600
and 1609, is an exception to this rule. Homma Saburoemon
kills a rival and the two surviving sons swear to avenge their
father's death. They pursue the murderer through the
countryside and one night the elder brother Iori succeeds in
confronting him. However, the long pursuit has taken its toll.
The boy is ill, weak and without companions to compensate
for his youth and inexperience. His simple virtue and determi-
nation are no match for Homma, and to the audience's
distress, he is killed before their eyes. Iori's death, of course,
sharpens his younger brother's determination. Enlisting the
aid of an older samurai he finally confronts Homma at the
Tenka Teahouse and succeeds in exacting his revenge.

*39. *Kawagishi no tsuki*, "Moon over the River"
 from the series *Setsugekka*, "Snow, Moon, and Flowers"
 late 1849 or early 1850
 Chūban diptych
 Signature: Hirosada
 Seal: Rankei
 Publisher: Kawaoto
 Collection: Donald Dame, Long Beach, California

This peaceful picture stands out in Hirosada's work
because the actors Ichikawa Shikō and Kataoka Gadō II are
shown, not stage roles, but as they might appear in private
life, relaxing on an open terrace beside a river by moonlight.
The actors' robes and the wooden railing behind them are
decorated with their personal emblems. The series title calls
for companion pictures of snow and cherry blossoms, but this
is the only picture from the set which is presently known.

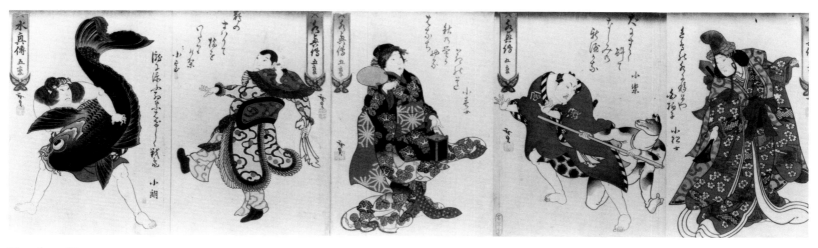

Number 40

40. Onoe Tamizō II performing five roles
in *Saishiki matsu no suisei,* "Bright Torrent by a Pine,"
 Kado Theater
from *Suikōden gohen,* "Water Stories with Five Changes"
8/1850
Chūban pentaptych
Signature: Hirosada
Seal: Ko
Publisher: Meikōdō
Collection: Ikeda Bunko Library, Japan

The finale for the performance at the Kado Theater in the eighth month of 1850 was a dance of five quick costume changes by the actor Onoe Tamizō II (1799-1886). From right to left, Tamizō appeared as a ceremonial dancer (*shirabyōshi*), a drunken servant, a young girl with an insect cage, a Chinese dancer and a fisherman grasping a giant carp. The play title, "Bright Torrent by a Pine," suggests a flurry of colorful activity before the painted backdrop of a large pine tree that was used in the Nō theater and also appeared in many kabuki dance

plays. "Water Stories," the title on each print, seems to link the name of the play with the Chinese novel *Shui hu chuan* ("Stories of the Water Margin") which was popular in Japan at this time and was pronounced *Suikoden* in Japanese. Each of the pictures is accompanied by a short verse, at least two of which were written by women. These read (from right to left):

"The dancer is a colorful bird splashing in the water,"
Irodori no mizu ni . . . ru ya shirabyōshi. By Komatsujo

"Drunk with his dog: the good old servant,"
Inu ni kite yoite najimi no . . . kana. By Koraku

"The autumn fireflies are the color of falling cherry blossoms," *Hana chiyuru aki no hotaru ga hana no iro.* By Koharujo

"The rooster circled around and crossed the bridge,"
Niwatori no mawarite hashi o watarikeri. By Komuro

"The maple leaves beside the waterfall waged a strong battle," *Taki ni sou momiji hageshiku tatakikeri.* By Koaki

For an early portrait of Tamizō II see catalogue no. 1; for another picture of the actor in a dance of quick costume changes, see catalogue no. 53.

*41. Nakamura Utaemon IV as Takechi Samanosuke
Nakayama Tamashichi as Sutewakamaru
in *Chigogafuchi koi no shiranami*, "The Chigo Deeps and
the White Waves of Love," Naka Theater
8/1850
Chūban diptych
Signature: Hirosada
Seal: Sada han
Publisher: Isekichi
Collection: Donald Dame, Long Beach, California

The Chigo Deeps is an area off the island of Enoshima
where a young temple page (*chigo*) named Shiragikumaru
committed suicide in the twelfth century to avoid choosing
between two priests who loved him. In "The White Waves of
Love" this legend was combined with the story of the six-
teenth century outlaw Ishikawa Goemon to explain the
sequence of events that eventually led to Goemon's capture.
Although the libretto for the play no longer survives, the
story can be deduced from Hirosada's prints for the perform-
ance. In the prologue to the play, the ghost of Takechi Mitsu-
hide rises from the waves and speaks to Sutewakamaru, a
young temple page. At the end of their conversation the child
promises to avenge Mitsuhide's death by killing the powerful
general Mashiba Hisayoshi.

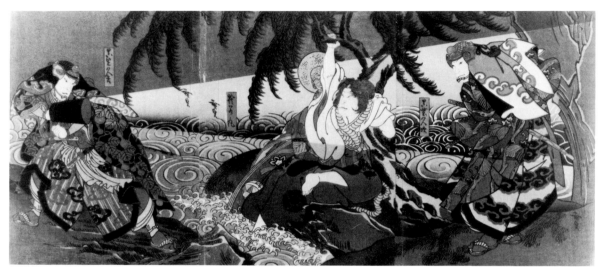

Number 42

42. Jitsukawa Ensaburō as Mashiba Hisatsugu
 Nakamura Utaemon IV as Sutewakamaru
 Mimasu Daigoro IV as Mashiba Hisayoshi
 in *Chigogafuchi koi no shiranami*, "The Chigo Deeps
 and the White Waves of Love," Naka Theater
 8/1850
 Chūban triptych
 Signature: Hirosada
 Collection: Donald Dame, Long Beach, California

The beginning of "The White Waves of Love" is described in the previous entry (catalogue number 41). As Sutewakamaru grows older he displays a bold, aggressive temperment. However, like Shiragikumaru in the twelfth century, he decides to take his own life. Binding himself to a statue of the Bodhisattva Jizō on a rock by the Chigo Deeps, he waits for the tide to rise and drown him. Instead, he is discovered by Hisayoshi and his son Hisatsugu and they rescue him. Hisatsugu has, in the meantime, been threatened by Goemon's mother, Ishida no Tsubone (see catalogue no. 13), but has spared her life as well; so despite his promise to Mitsuhide's ghost, Sutewakamaru is under a double obligation. Later in the play Sutewakamaru becomes Goemon, the celebrated outlaw and, in disguise, enters Hisatsugu's heavily guarded palace and confronts him. At this crucial moment, his personal obligations outweigh his promise to the ghost and he spares Hisatsugu. Goemon, however, is captured and put to death as a criminal. Hirosada's picture of Sutewakamaru's rescue is printed in shades of grey, except for the area which is brightly lit by Hisayoshi's lantern.

112

*43. Onoe Tamizō II as Soma Tarō
Arashi Rikaku II as Utō Yasukata
Arashi Rikan III as Takiyasha Hime
in *Soma tarō mebae bundan*, "The Story of Tarō, Scion of
the Soma Clan," Wakadayū Theater
10/1850
Chūban triptych
Signature: Hirosada
Publisher: Kashimadō
Engraver: Hori Uchitora
Collection: Donald Dame, Long Beach, California

Utō Yasukata was the son of a retainer of the ambitious courtier Taira no Masakado (see catalogue no. 30) who was forced to commit suicide after Masakado's death. In this scene, his ghost appears to Masakado's children, Soma Tarō and Takiyasha Hime, urging them to restore the family's fortunes and avenge their father's death. Takiyasha, just returned from her stay on Mt. Tsukuba performing ascetic practices, holds a spear. Her brother holds the brocade banner of the Soma clan.

*44. Kataoka Gadō II, Jitsukawa Ensaburō and Arashi
Rikaku II as lion dancers
in *Sannin shakkyō aratama asobi*, "Three Men Playing on
the Stone Bridge at the New Year"
1/1851
Chūban triptych
Signature: Hirosada
Collection: Donald Dame, Long Beach, California

On the sacred mountain Tientai in China a natural stone bridge spanned a deep chasm. It was arched like a tortoise shell some seventy feet long and two feet thick. During the Xin Dynasty an Indian monk climbed the mountain and had a vision of the five hundred arhats, or disciples of Buddha. Later, the mountain was associated with the Bodhisattva Monju, a deity of wisdom and patron of scholarship. It was believed that the Stone Bridge led directly to Monju's Paradise and, since the Bodhisattva's vehicle was a lion, this animal came to be associated with the bridge. In a Nō play based on this legend, a Japanese courtier Ōe Sadamoto took religious orders, adopted the name Jakushō Daishi and travelled to China as a pilgrim. At Mt. Tientai, a child tells him to visit the Stone Bridge and he has a vision there of lions playing among the peonies. In this adaptation of the play three lions dance at the foot of the bridge.

Hirosada also designed another triptych with a similar title of three actors as New Year street performers. Both pictures are imaginary groupings: the actors were all active in Ōsaka in 1850 and 1851 but they performed at two different theaters. The subjects and titles of the prints indicate that they were published at the New Year and the style of the pictures suggests a date of 1851.

*45. Nakamura Utaemon IV as Nuregami Chōgorō
Mimasu Daigorō IV as Oseki
Kataoka Ichizō I as the wine seller Kambei
Jitsukawa Ensaburō as Hanaregoma Chōkichi
in *Hanazumo chōchō no mombi*, "Amateur Wrestling:
 A Special Day for the Butterflies," Naka Theater
3/1851
Chūban triptych
Signature: Hirosada
Collection: Ikeda Bunko Library, Japan

Upset and fearful of her brother's quarrelsomeness, Oseki berates her brother Chōkichi and publicly calls him an outlaw. Chōkichi is so ashamed of her accusation that he prepares to commit suicide, feeling that nothing short of this could vindicate him. As Chōkichi is about to kill himself, his rival Chōgorō appears. But Chōgorō has undergone a change of heart and urges Chōkichi to continue living. The scene ends as the two men commingle their blood in a cup, drink it and swear brotherhood. In the original play, the confrontation between Oseki and her brother takes place at the shop where he works as a rice huller. In this version, it occurs on a bridge over the Doton Canal, in Ōsaka, with the banners of kabuki theaters silhouetted on the skyline. Kambei, a wine vendor, witnesses Oseki's accusations and supplies the cup with which the two men pledge their friendship. For an earlier scene from the play, see catalogue no. 24b.

*46 Nakamura Utaemon IV as Kō no Moronao
Kataoka Ichizō I as the tea master Risai (?)
Mimasu Daigorō IV as Enya Hangan
in *Kanadehon chūshingura*, "A Writing Manual for the
 Treasury of Loyal Retainers," Naka Theater
5/1851
Chūban triptych
Signature: Hirosada
Seal: Rankei (on late impressions)
Publisher: Kawaoto (on late impressions)
Collection: Haber Collection, New York

In the dramatization of the vendetta of the forty-seven samurai, the shogun honors Lord Enya and Lord Momonoi by choosing them to greet the imperial envoys who visited Edo Castle once a year. In order to perform their duties satisfactorily the men need instruction in protocol and etiquette from the shogun's Grand Master of Ceremonies, Kō no Moronao. A venal man, Moronao refuses to give instruction until the men have bribed him generously. Momonoi acquiesces, but Lord Enya is either too naive to understand the situation or too inflexible to give in. As the ceremony draws closer Moronao begins to insult Enya and in Hirosada's diptych for the first scene in Act 3 of the play, Moronao taunts the supplicant. Enya's patience finally snaps, he loses his temper and, in an unpardonable breach of etiquette, he draws his sword and tries to kill the wicked man. Other courtiers in the palace, however, hear the commotion and rush to separate them. In Hirosada's triptych Moronao falls back stunned, Enya's sword piercing the floor in front of him, as the courtiers struggle to hold Enya until his rage passes. The Chinese inscription on the right sheet of the triptych was written by Senrō.

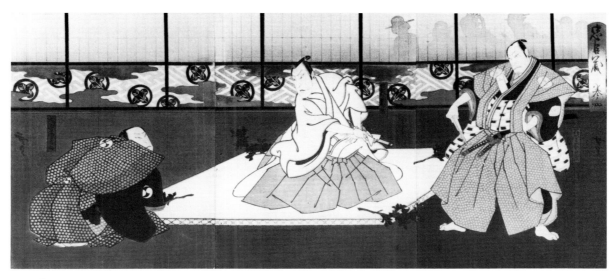

Number 47

47. Jitsukawa Ensaburō as Sekidō Umanojō
Mimasu Daigorō IV as Enya Hangan
Nakamura Utaemon IV as Ōboshi Yuranosuke
in *Kanadehon chūshingura*, "A Writing Manual for
the Treasury of Loyal Retainers," Naka Theater
5/1851
Chūban triptych
Signature: Hirosada
Collection: Haber Collection, New York

The penalty for drawing one's sword in the shogun's palace was death and confiscation of one's domains; the law permitted no exceptions. After the attack on Moronao, Enya was confined to his quarters and, after solemn deliberations, the governing council ordered him to commit ritual suicide. A court official, Sekidō, was dispatched to witness and confirm Enya's death. This ritual is the subject of Hirosada's print. As Enya plunges the dagger into his belly his chamberlain Yuranosuke appears. He had left Akō as soon as he heard of his master's disgrace and arrived in Edo in time to see him once again. As Enya dies, Yuranosuke resolves to avenge his death. In 1851 Hirosada designed eight polyptychs with full-length figures for the first seven acts of "The Treasury of Loyal Retainers," each with a different color scheme reflecting the mood of the scene portrayed. He also designed four groups of large heads for the play, all of them larger in proportion to the picture frame and simpler in design, than the large heads he had designed for the last Ōsaka performance of the play in 1849 (see catalogue nos. 27 and 28).

*48. Nakamura Utaemon IV as Danshichi Mohei
Nakayama Nanshi II as Tomi
in *Yadonashi danshichi shigure no karakasa*, "Homeless
Danshichi: An Umbrella in the Rain,"
Naka Theater
5/1851
Chūban diptych
Signature: Hirosada
Collection: Donald Dame, Long Beach, California

The Udagawa family in Minatogawa fell from fortune when the family heirloom, a precious dagger, was stolen. Their son moved to the port town of Sakai, adopted the name Danshichi Mohei, supported himself as a fish seller and became famous for his quick and irascible temper. Mohei loved a prostitute named Tomi who worked at the Iwai Bath House and succeeded in keeping her from Kazuemon, a rival. Unknown to Mohei, Kazuemon possessed the stolen sword and certificate of authenticity. The bath house owner was Mohei's friend and he convinced Tomi that the sword and the family's fortunes might be recovered if she pretended to reject Mohei and temporarily give in to Kazuemon. Tomi reluctantly agreed to do this but, when she broke her engagement to Mohei, he fell into a jealous rage, ran amok and killed the bath house owner and several other people. Hirosada depicts the moment when Mohei confronts his lover and she falls backwards in fear while raising her hand to protect herself.

49. Nakamura Utaemon IV as Danshichi Mohei
Nakayama Nanshi II as Tomi
in *Yadonashi danshichi shigure no karakasa*, "Homeless
Danshichi: An Umbrella in the Rain,"
Naka Theater
1/1851
Chūban format
Signature: Hirosada
Seal: Konishi Gochō
Publisher: Kinkadō
Collection: Ikeda Bunko Library, Japan

This is a close-up view of the scene portrayed in the previous print (catalogue no. 48). Tomi raises her sleeve helplessly and the white flesh exposed by her collar makes her seem especially vulnerable. The picture is from a series of several paired half-length portraits of actors with the names of their roles written in tile-shaped cartouches (see catalogue no. 52).

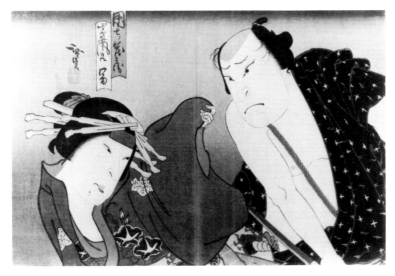

Number 49

*50. Mimasu Daigorō IV as the playwright Namiki Shōzō
 Nakamura Utaemon IV as Danshichi Mohei
 Nakayama Nanshi II as Tomi
 in *Yadonashi danshichi shigure no karakasa*, "Homeless
 Danshichi: An Umbrella in the Rain,"
 Naka Theater
 5/1851
 Chūban triptych
 Signature: Hirosada
 Publisher: Unread
 Collection: Ikeda Bunko Library, Japan

At the moment Mohei is about to strike Tomi, a crowd appears led by Namiki Shōzō, the author of the play. Shōzō remonstrates with Mohei, begging him to be patient and control his temper. As the author, he is aware that Tomi's estrangement is only feigned, that the heirloom sword will be recovered through her self-sacrificing efforts and that Mohei will restore his family's fortunes. He knows, in other words, that his story has a happy ending. He cannot say this, however; nor can he control the actions of his character who now displays a life and will of his own. Mohei spares Tomi but, still enraged, escapes from the crowd and runs amok at the Iwai Bath House, killing his friend the proprietor and several innocent people. When he finally comes to his senses and realizes the enormity of his crime, he is stricken with remorse and takes his own life.

 This is one of Hirosada's finest night scenes. Namiki Shōzō stands at the right raising a lantern inscribed with his family name.

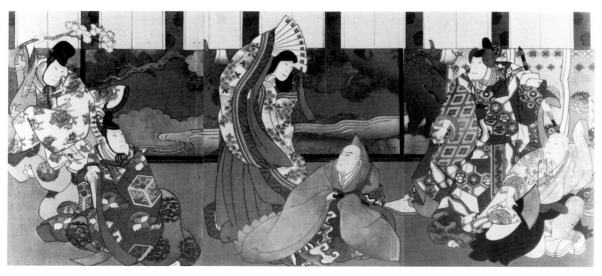

Number 51a

51a. Onoe Tamizō II as Kisen Hōshi
Jitsukawa Ensaburō as Ariwara no Narihira
Ichikawa Ebizō V as Sōjō Henjō
Nakamura Utaemon IV as Ono no Komachi
Mimasu Daigoro IV as Ōtomo no Kuronushi
Kataoka Gadō II as Bun'ya no Yasuhide
c. 1/1850

Chūban triptych

Signature: Hirosada ga

Collection: Philadelphia Museum of Art, Pennsylvania
Purchased by subscription and with a donation
from the Lola Downin Peck Fund.

In the first month of 1834, soon after his return to
Ōsaka from a long sojourn, the actor Nakamura Shikan II
performed a popular dance of quick costume changes in
which he impersonated five of the Six Immortal Poets of the
Heian court. In the spring of 1850, after another long absence,
the actor returned to Ōsaka and Hirosada designed an
imaginary tableau of the Six Poets with Utaemon IV (as he
was now called) surrounded by five other leading actors of the
day. Two years later, shortly before his death, Utaemon
repeated the dance he had first performed in 1834. To com-
memorate the event, Hirosada altered the blocks for the 1850
print, removing the background and replacing the portrait
faces (see catalogue no. 51b). Hirosada also designed four more
sets of prints for the play: six full-length portraits, six close-up
portraits in the *chūban* format, six miniature close-up portraits
and three double half-length portraits (see catalogue no. 52).

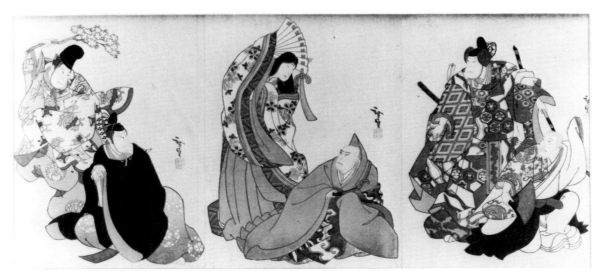

Number 51b

51b. Nakamura Utaemon IV as Narihira, Kisen Hōshi,
Bun'ya no Yasuhide, Sōjō Henjō, Ōtomo no Kuronushi
Nakayama Nanshi II as Ono no Komachi
in *Yosooi rokkasen*, "The Six Immortal Poets in Full
Dress," Naka Theater
1/1852
Chūban triptych
Signature: Hirosada
Collection: Travis and Jane Bogard,
Berkeley, California

*52. Nakamura Utaemon IV as Kisen Hōshi, Ariwara no
 Narihira, Ōtomo no Kuronushi, Sōjō Henjō and
 Bun'ya no Yasuhide
 Nakayama Nanshi II as Ono no Komachi
 in *Yosooi rokkasen*, "The Six Immortal Poets in Full
 Dress," Naka Theater
 1/1852
 Chūban triptych
 Signature: Hirosada
 Seal: Konishi Gochō
 Publisher: Kinkadō
 Collection: Private collection, New York

This group, with its clear, brilliant colors, was one of five sets of prints that Hirosada designed to commemorate the last dance play performed by the actor Utaemon IV before his untimely death in the second month of 1852 (see catalogue no. 51). It was Hirosada's last work with paired half-length portraits of actors, a format he first explored in the fourth month of 1849 after the death of Onoe Kikugorō III (see catalogue nos. 21, 22 and 49).

*53. Onoe Tamizō II as *minori no shiragitsune*, (the White Fox
 of Plenty), a street vendor, *ukare no kaeru* (a fickle
 frog), and a standard bearer
 in *Honen sugata*, "Aspects of a Plentiful Year,"
 Wakadayū Theater
 1/1852
 Chūban triptych
 Signature: Hirosada
 Collection: Ikeda Bunko Library, Japan

In the spring of 1852, Onoe Tamizō performed the roles of the outlaw Ishikawa Goemon and the youthful Hideyoshi in the historical drama *Keisei koi no shiranami*, "The Courtesan and the White Waves of Love." For the grand finale Tamizō performed a humorous pantomime dance of quick changes which seems to have begun as a prayer for bountiful harvests and prosperity in the coming year. Hirosada shows us four of Tamizō's roles in the dance: an old man carrying sheaves of rice, a street vendor, a frog and a standard bearer. The old man is actually a white fox, messenger of the god responsible for full harvests. Dances with quick costume changes usually included five, seven, or nine roles and published records for this performance say the Tamizō also performed a pony dance.

*54a. Kataoka Gadō II as Inuzuka Shino
Kataoka Ichizō II as Inugai Kempachi
in *Hana no ami tsubomi no yatsubusa*, "The Eight Buds of
 Plum Blossom," Chikugo Theater
2/1852
Chūban
Signature: Hirosada
Seal: Han Sada
Collection: Donald Dame, Long Beach, California

The "Eight Dogs" of the Satomi clan were eight brothers born to different mothers and raised without any knowledge of one another whose destiny was to seek one another out and form a family. In this scene, two of the brothers, Shino and Kempachi, are both in search of a precious sword. They meet as antagonists and battle one another on the roof of Horyūkaku, the tower of Koga Castle which stood beside the Tone River. At the climax of their fight, they both slip off the roof, lose consciousness, fall into a boat and drift downstream. They soon recover and talk and in the ensuing conversation discover that they are brothers. Around the beginning of 1851, Hirosada designed an unusual triptych for an unrecorded performance of this scene (see catalogue no. 54b). Kempachi stands on the balcony of the tower looking up at Shino on the rooftop while three police huddle in confusion at the lower right.

54b. Jitsukawa Ensaburō as Inuzuka Shino
Kataoka Gadō II as Inugai Kempachi
in the Horyūkaku scene from Act 5 of "The Eight Buds
 of Plum Blossom"
Early 1850s
Chūban triptych
Signature: Hirosada
Seal: Ko
Publisher: Meikōdō
Collection: Ikeda Bunko Library, Japan
(Illustration only, not exhibited)

Number 54b.

Number 55a

55a. Arashi Rikaku II as Ume no Yoshibei
 Nakamura Tamashichi as the apprentice Chōkichi
 in *Akanezome nonaka no kakureido*, "Red Dye in the
 Hidden Well in the Countryside,"
 Chikugo Theater
 8 / 1852
 Chūban diptych
 Signature: Hirosada
 Seal: Konishi Gochō
 Publisher: Tenki (in black on later impressions)
 Collection: Ikeda Bunko Library, Japan
 (Illustration only, not exhibited)

"The Hidden Well" is a tragedy of desperate need and misunderstanding. Outlaws steal a precious heirloom from the family of Ume no Yoshibei, an Edo townsman. For 100 gold *ryō*, Yoshibei can both redeem the object and save a young couple from a needless separation. This is an enormous sum, however, and as his deadline approaches, Yoshibei grows frantic. Unknown to him, Yoshibei's wife locates the sum and her younger brother Chōkichi sets out through the night to deliver it. The boy is attacked by bandits and rescued by Yoshibei but both fail to recognize one another in the darkness. Yoshibei soon realizes that the youth has money and begs to borrow it. Chōkichi refuses and the desperate townsman kills him. Hirosada shows us the tense moment before Chōkichi's death: Yoshibei, sword drawn, threatens the boy who cringes before him, trying to conceal the coin pouch around his neck with his hands.

*55b. Arashi Rikaku II as Ume no Yoshibei
Nakamura Tamashichi as the apprentice Chōkichi
in *Akanezome nonaka no kakureido,* "Red Dye in the
Hidden Well in the Countryside,"
Chikugo Theater
8/1852
Preparatory drawings for the published prints; drawn in
brush and light colors and titled "Metal" *(Kin)*
Collection: Philadelphia Museum of Art, Pennsylvania
Purchased by subscription and with a donation
from the Lola Downin Peck Fund.

Hirosada's wash studies for the pair of close-up portraits
for the same scene repeat the spatial relationship between the
actors as they appeared on stage in the previous print. The
decorative cartouche at the top of the drawings inscribed with
the character for "Metal" indicates that Hirosada originally
meant to include this design in a set illustrating the Five
Elements.

*55c. Arashi Rikaku II as Ume no Yoshibei
Nakamura Tamashichi as the apprentice Chōkichi
in *Akanezome nonaka no kakureido,* "Red Dye in the
Hidden Well in the Countryside,"
Chikugo Theater
8/1852
Chūban diptych
Signature: Hirosada
Publisher: Daijin
Collection: Donald Dame, Long Beach, California

In the published version of the print Hirosada reversed
the position of the two figures. Yoshibei seems to be searching
for Chōkichi in the dark while the frightened boy tries to
protect the money and elude him. This diptych was published
soon after Hirosada's return from Edo and it is one of the
artist's most deeply emotional prints. The swordsman seems
implacable and the pink areas around Chōkichi's collar and
sleeves make him seem particularly vulnerable and helpless.

*56. Arashi Rikaku II as Ume no Yoshibei
Nakamura Tamashichi as the apprentice Chōkichi
in *Akanezome nonaka no kakureido*, "Red Dye in the
Hidden Well in the Countryside,"
Chikugo Theater
8/1852
Chūban format
Signature: Hirosada
Seal: Han Sada
Publisher: Daijin
Collection: Donald Dame, Long Beach, California

This is another print based on the unknowing murder of the young apprentice Chōkichi by his brother-in-law Yoshibei. While in Edo in 1852, Hirosada saw that a number of artists were designing prints called *harimaze* which combined pictures of various shapes and styles with calligraphy or other decorative elements. Returning to Ōsaka he designed a number of these prints himself, combining two close-up portraits of actors with an abbreviated title written in white on black at the top of the print and role names written in a decorative script below. This picture was number eight from a set of ten which included at least three scenes from "The Hidden Well."

*57a. Arashi Rikaku II as Sambasō
in *Hatsuyagura tanemaki sambasō*, "Sambasō Sows Seeds
from the New Tower," Chikugo Theater
8/1852
Chūban format
Signature: Hirosada
Seal: Konishi Gochō
Publisher: Kinkadō
Collection: Ikeda Bunko Library, Japan

In the fourth month of 1852, the Chikugo Theater burned. Reconstruction began at once and the new theater opened four months later. To celebrate the opening Arashi Rikaku performed a dance based on *Okina*, a Nō play which was usually presented after a solemn ritual of purification to ask the gods for peace and prosperity for the nation and long life for its people. During the eighteenth century kabuki theaters began each day's performance with a purification ceremony at three or four in the morning with a low-ranking actor performing the dance of Sambasō. Leading actors only performed the role on special occasions such as this, which not only marked the opening of the new theater, but was also part of Rikaku's farewell performance before he left Ōsaka to go on tour. Hirosada designed three prints of Rikaku in this role: the full-length and close-up portraits exhibited here, and a horizontal half-length portrait.

Number 57b

57b. Arashi Rikaku II as Sambasō
in *Hatasuyagura tanemaki sambasō*, "Sambasō Sows
 Seeds from the New Tower," Chikugo Theater
8/1852
Chūban format
Signature: Hirosada
Seal: Sada han
Publisher: Isekichi
Collection: Donald Dame, Long Beach, California

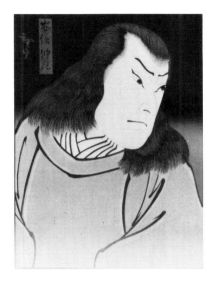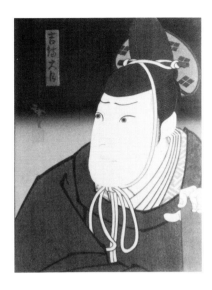

Number 58

58. Ichikawa Danzō VI as Kibi Daijin
 Arashi Rikaku II as Abe no Nakamaro
 Fujikawa Tomokichi III as Gentō's wife
 in *Kin'u gyokuto wakoku no irifune*, "The Golden Crow,
 the Jade Rabbit and the Ship Arriving in Japan,"
 Kado Theater
 10/1852
 Chūban triptych
 Signature: Hirosada
 Seal: Sada
 Publisher: Kinkodō
 Collection: Donald Dame, Long Beach, California

In 716 two Japanese courtiers, Kibi Daijin and Abe no Nakamaro, were sent as imperial envoys to the Chinese court. During the next twenty years they studied mathematics, music, military strategy and other arts. Kibi returned to Japan safely but Nakamaro was shipwrecked and died in China without transmitting the secret of the Chinese almanac to Japan. In "The Golden Crow" Nakamaro's spirit communicates with Kibi and after many vicissitudes the valuable calculations finally reach Japan. In this triptych the Chinese empress witnesses a dialogue between the two friends. Hirosada designed two other pictures of the scene: a diptych with Nakamaro holding up a scroll toward his friend and a *harimazel* sheet of the moment after the transfer with Kibi holding the scroll in his hand.

*59. Onoe Tamizō II as Sambasō and a lion dancer
 Nakayama Nanshi II as the spirit of the Stone Bridge
 in *Chiyo kakete iwau shimadai*, "A Stand to Celebrate
 Long Life," Naka Theater
 10/1852
 Chūban triptych
 Signature: Hirosada
 Collection: Donald Dame, Long Beach, California

Among Hirosada's last prints were these three portraits
with gold backgrounds of Tamizō and Nanshi in the dance
finale to the historical play presented at the Naka Theater at
the end of 1852. Onoe Tamizō first performed the Sambasō
dance then changed into a lion dancing with its cub at the
Stone Bridge at Mt. Tientai in China. In the course of the
play, the mother lion pushes her young cub off a steep cliff to
test its strength and watches anxiously as it struggles back and
rejoins her. The sentiment expressed in the play may have
prompted Hirosada's sudden retirement in favor of his untried
fourteen year old pupil, Hirokane. At any rate, Hirosada
designed only one triptych after this date; all the other prints
signed Hirosada that appeared between 1853 and 1861 were
designed by his young pupil. The contemporary broadsides
issued for the play give two pronunciations of the play title:
one beginning *Chiyo kakete*, the other *Chiyo no kotobuki*. The
general meaning is the same.

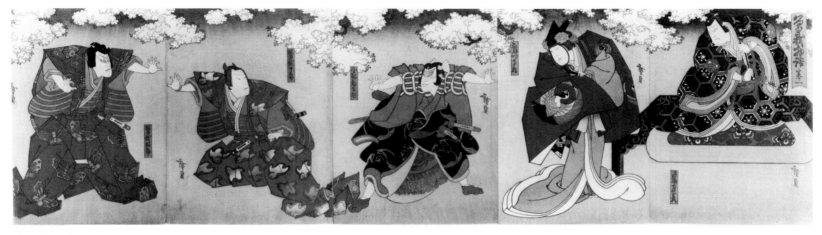

Number 60a.

60a. **Hirosada II**
Ichikawa Danzō IV as Kudō Suketsune
Nakamura Tomokichi as Maizuru Hime
Nakamura Tamashichi as Asahina
Kataoka Gadō II as Soga no Jūrō
Ichikawa Ebizō V as Soga no Gorō
in *Keisei soga haru no fujikane*, "Kagekiyo, the Soga
 Brothers and Mt. Fuji in the Spring," Kado Theater
Ōban pentaptych
Signature: Hirosada
Seal: Rankei?
Publisher: Kawaoto?
Collection: Ikeda Bunko Library, Japan

The Soga Brothers, Jūrō and Gorō, were sons of a man who was murdered in the twelfth century on the orders of a feudal lord, Kudō Suketsune. The boys grew up planning revenge and eventually accomplished it. In the opening scene of this dramatization of the legend, the two brothers confront their enemy for the first time, but are prevented from precipitous action by Kudō's retainer, Kobayashi Asahina and his sister Maizuru. For his debut as an independent artist Hirosada II designed full-figure polyptychs for all eight acts of the play. He also designed seven polyptychs with close-up portraits of the actors in the same roles for the first six acts of the play.

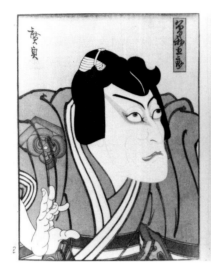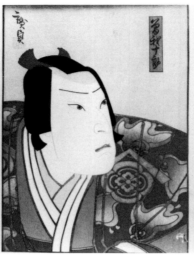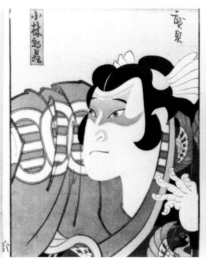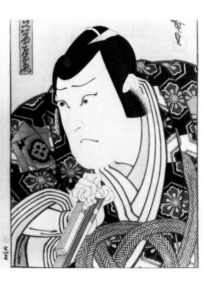

Number 60b

60b. **Hirosada II**
 Ichikawa Danzō IV as Kudō Suketsune
 Nakamura Tamashichi as Kobayashi Asahimaru
 Kataoka Gadō II as Soga no Jūrō
 Ichikawa Ebizō V as Soga no Gorō
 in *Keisei soga haru no fujikane*, "Kagekiyo, the Soga
 Brothers and Mt. Fuji in the Spring," Kado Theater
 1 / 1853
 Chūban tetraptych
 Signature: Hirosada
 Seal: Rankei
 Publisher: Kawaoto
 Collection: Ikeda Bunko Library, Japan

In designing close-up portraits of actors, Hirosada II simply enlarged the faces of figures in his full-length prints. His teacher, on the other hand, always chose a different moment in the action for his full-length and close-up portraits. In addition to the pictures mentioned previously (catalogue no. 60a), Hirosada II also designed at least one pair of quarter-block close-up portraits of actors in this play which he signed Sadahiro. They were probably designed and published in anticipation of the New Year performance at the end of 1852 before Hirosada I retired. He then redesigned them in *chūban* format and changed the signature to Hirosada.

130

BIBLIOGRAPHY

Genshoku ukiyoe daihyakka jiten. 11 vols. Tokyo: Taishukaku, 1980–82.

Hajek, Lubor. *The Osaka Woodcuts.* London: Spring Books, 1960.

Ihara, Toshirō, ed. *Kabuki nempyō.* 8 vols. Tokyo: Iwanami Shoten, 1956–63.

Iizuka, Tomoichirō. *Kabuki saiken.* 2 vols. Tokyo: Watanabe, 1893.

Inoue, Kazuo, and Watanabe Shōzaburō, eds. *Ukiyoeshi den.* Tokyo: 1931.

Kansai daigaku shozō ōsaka kankei shiryō mokuroku. Ōsaka: 1960.

Kennedy, Robin. *A Catalogue of Ōsaka Prints.* London: 1979.

Keyes, Roger and Keiko Mizushima. *The Theatrical World of Ōsaka Prints.* Boston: David R. Godine in association with the Philadelphia Museum of Art, 1973.

Kōjien. Compiled by Izuru Shimmura. Tokyo: Iwanami Shoten, 1966.

Kokusho sōmokuroku. 8 vols. Tokyo: Iwanami Shoten, 1963–72.

Kuroda, Genji. *Kamigatae ichiran.* Kyoto: Satō Shōtarō Shoten, 1929.

Lühl, Hendrick. *Osaka-holzschnitte.* Dortmund: Federal Republic of Germany: Harenberg, 1982.

Matsudaira, Susumu. *Kamigata ukiyoe 200 nen ten.* Tokyo: Riccar Museum, 1975.

Matsudaira, Susumu. *Hankyū gakuen ikeda bunko shozō shibai banzuke mokuroku.* Ōsaka: Ikeda Bunko Library, 1981.

Naniwa sōsho. 16 vols. plus supplement. Ōsaka: Naniwa sōsho, 1926–30.

Ōsaka furitsu toshokanzō shibai banzuke mokuroku. Ōsaka: Ōsaka furitsu toshokan, 1968.

Sadanobu II, Hasegawa. "Reminiscences of Bookshops" (*Ezōshiten no tsuioku*). *Anona.* vol. 7, 1929.

Sekine, Kinshirō. *Honchō ukiyoe gajinden.* Tokyo, 1899.

Sotheby Parke Bernet, Inc. *Fine Japanese Prints, Illustrated Books and Paintings.* London, 28 October 1981.

Toda, Kenji. Edited by Teruji Yoshida. *Ryerson Collection of Japanese and Chinese Illustrated Books.* Chicago: The Art Institute of Chicago, February 1931.

Van Doesburg, Jan. "New Aspects in the Field of Ōsaka Chūban Prints." *Andon.* No. 10. The Hague: Society for Japanese Arts and Crafts, 1983.

Yoshida, Teruji. *Ukiyoe jiten.* 3 vols. Tokyo: Gabundō, 1965–71.

Zoku enseki jisshu. 3 vols. Tokyo: Hirotani Kokusho, 1909. Reprinted 1927.

Selected Kabuki Bibliography

Brandon, James R. *Chūshingura: Studies in Kabuki and the Puppet Theater.* Honolulu: University of Hawaii Press, 1982.

Brandon, James R., Malm, William P., and Shively, Donald H. *Studies in Kabuki: Its Acting, Music, and Historical Context.* Honolulu: University of Hawaii Press, 1978.

Ernst, Earle. *The Kabuki Theatre.* New York: Oxford University Press, 1956.

Harr, Francis. *Japanese Theatre in Highlight: A Pictorial Commentary.* Rutland, Vermont and Tokyo, Japan: Charles E. Tuttle Company, 1952.

Kincaid, Zoë. *Kabuki: The Popular Stage of Japan.* London: Macmillan and Co., Limited, 1925.

Scott, A.C. *The Kabuki Theatre of Japan.* London: George Allen & Unwin Ltd., 1956.

Shaver, Ruth M. *Kabuki Costume.* Rutland, Vermont and Tokyo, Japan: Charles E. Tuttle, Company: Publishers, 1966.

Toshio, Kawatake. *A History of Japanese Theater II: Bunraku and Kabuki.* Yokomama: Kokusai Bunka Sinkokai (Japan Cultural Society), 1971.

Photography sources for figures as credited; illustrations in catalogue sections and black and white and color plates by Steve Bork, Custom Graphics, Westminster, CA except for catalogue no. 6: Will Brown, Philadelphia, PA; no. 17: Joan Broderick, Philadelphia, PA; nos. 5a and 9: Achenbach Foundation for Graphic Arts, San Francisco, CA; nos. 13c, 24b, 28b, 54b, 55a: Ikeda Bunko Library, Ōsaka, Japan; no. 52: private collection, New York; nos. 1, 2, 3, 4, 5b, 11, 13a, 13b, 13c, 15, 17, 21a, 21b, 21c, 24a, 24b, 28b, 30, 32, 35, 36, 37a, 37b, 40, 42, 47, 49, 51a, 51b, 54b, 57b, 58, 60a, 60b: Wendell Eckholm, Long Beach.

COLOPHON

This catalogue was designed in Newport Beach by Kirsten Jacobs Whalen, and lithographed in an edition of 2,000 on 100# Quintessence by Queen Beach Printers, Inc., Long Beach, California. The type was set in Goudy Old Style by Queen Beach Printers, Inc.